COLOR YOUR OWN
STAR WARS

Artists:

LEINIL YU, GERRY ALANGUILAN,

JOHN CASSADAY, HUMBERTO RAMOS, MIKE McKONE,

J. SCOTT CAMPBELL, ALAN DAVIS, MARK FARMER, GREG LAND,

SARA PICHELLI, JOE QUESADA, MARK MORALES, STUART IMMONEN,

WADE VON GRAWBADGER, SIMONE BIANCHI, TONY HARRIS,

JORGE MOLINA, CAMERON STEWART, MARCO CHECCHETTO,

PEPE LARRAZ, ALEX MALEEV, MIKE DEODATO, MARK BROOKS,

TERRY DODSON, RACHEL DODSON, JOËLLE JONES,

SALVADOR LARROCA, CLAY MANN & EMA LUPACCHINO

Series Editors:

JORDAN D. WHITE & HEATHER ANTOS

For Lucasfilm:

Creative Director: **MICHAEL SIGLAIN**

Senior Editor: **FRANK PARISI**

Lucasfilm Story Group: **RAYNE ROBERTS, PABLO HIDALGO,**
LEELAND CHEE & MATT MARTIN

Collection Editor **JENNIFER GRÜNWALD**
Associate Editor **SARAH BRUNSTAD**
Associate Managing Editor **KATERI WOODY**
Editor, Special Projects **MARK D. BEAZLEY**
VP Production & Special Projects **JEFF YOUNGQUIST**
SVP Print, Sales & Marketing **DAVID GABRIEL**
Book Designer **ADAM DEL RE**

Editor in Chief **AXEL ALONSO**
Chief Cre

Execut

LUCASFILM

COLOR YOUR OWN STAR WARS. First printing 2016. ISBN# 978-1-302-90094-6. Published by MARVEL WO ILICATION: 135 West 50th
Street, New York, NY 10020. STAR WARS and related text and illustrations are trademarks and/or copyright s. © & TM Lucasfilm Ltd.
No similarity between any of the names, characters, persons, and/or institutions in this magazine with those which may exist is purely
coincidental. Marvel and its logos are TM Marvel Characters, Inc. **Printed in the U.S.A.** ALAN FINE, Presider agement; JOE QUESADA,
Chief Creative Officer; TOM BREVOORT, SVP of Publishing; DAVID BOGART, SVP of Business Affairs & Opera Development, Asia; DAVID
GABRIEL, SVP of Sales & Marketing, Publishing; JEFF YOUNGQUIST, VP of Production & Special Projects; DAN CARR, Executive Director of Publishing Technology; ALEX MORALES, Director of Publishing Operations;
SUSAN CRESPI, Production Manager; STAN LEE, Chairman Emeritus. For information regarding advertising in Marvel Comics or on Marvel.com, please contact Vit DeBellis, Integrated Sales Manager, at vdebellis@
marvel.com. For Marvel subscription inquiries, please call 888-511-5480. **Manufactured between 8/12/2016 and 9/19/2016 by SHERIDAN, CHELSEA, MI, USA.**

10 9 8 7 6 5 4 3 2 1

D1366774

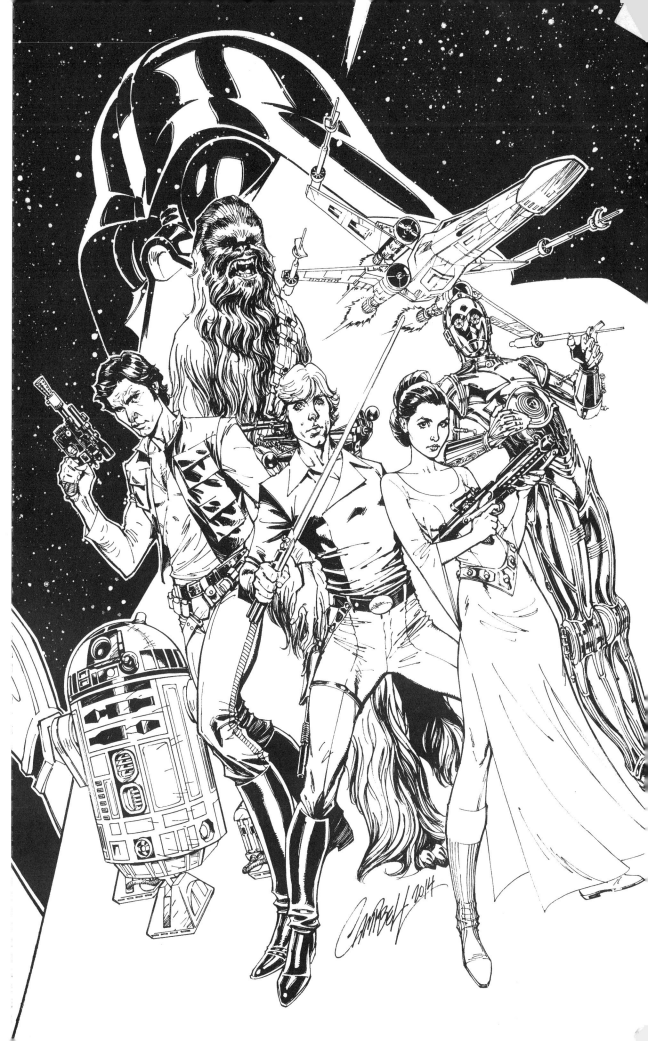

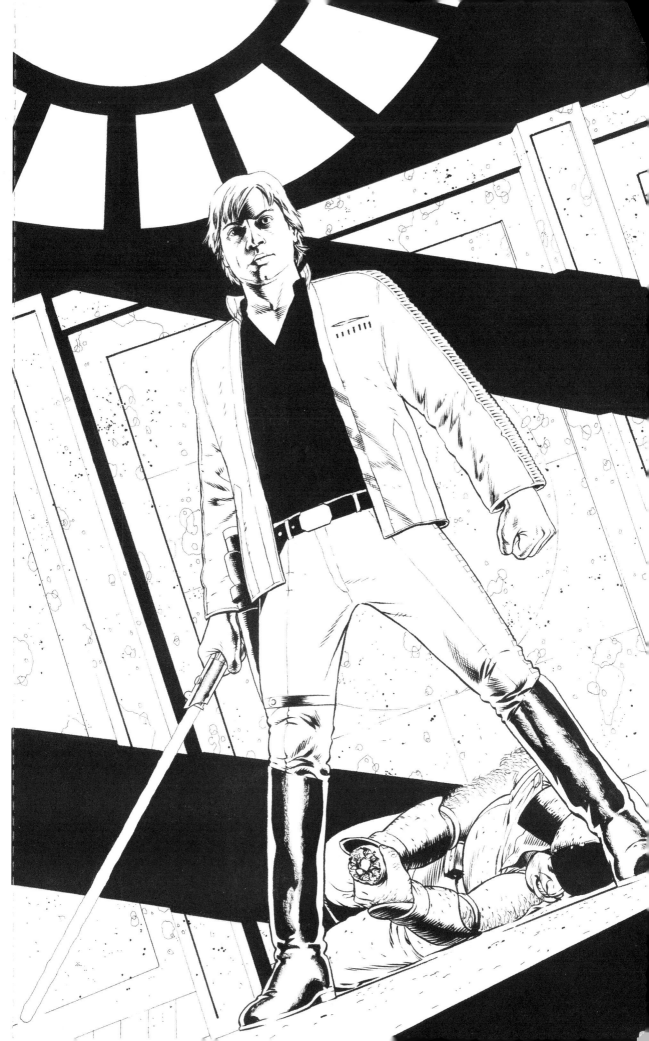

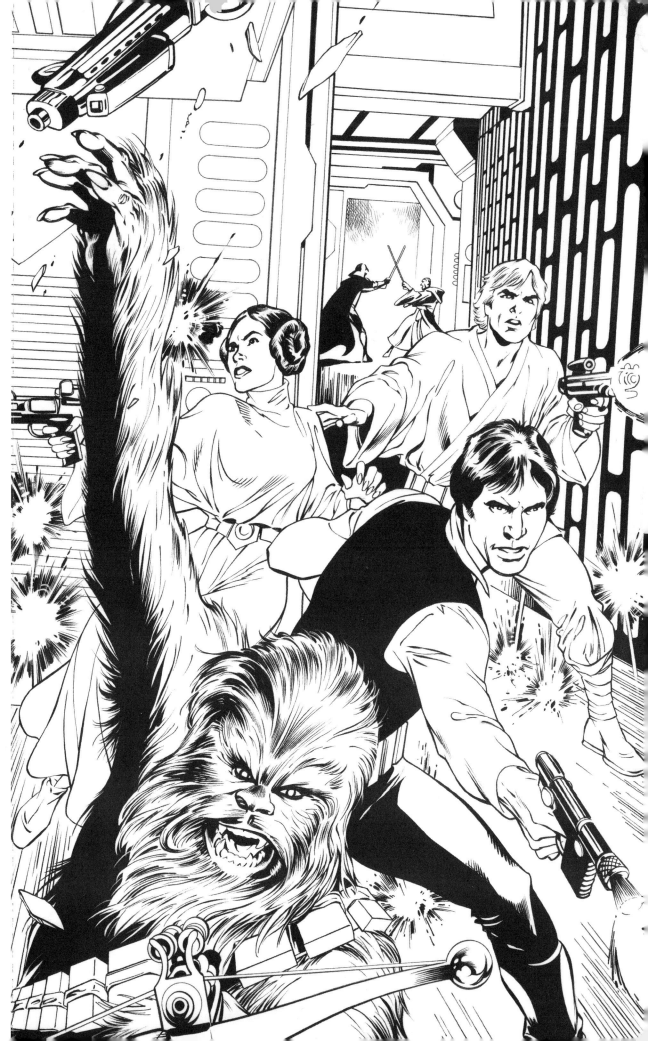

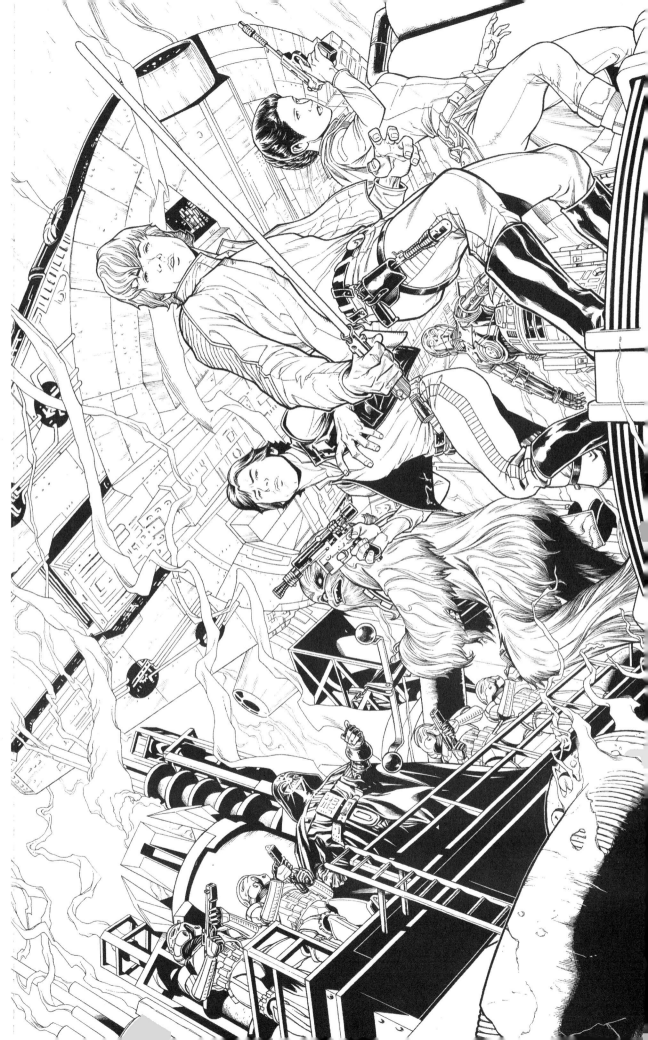

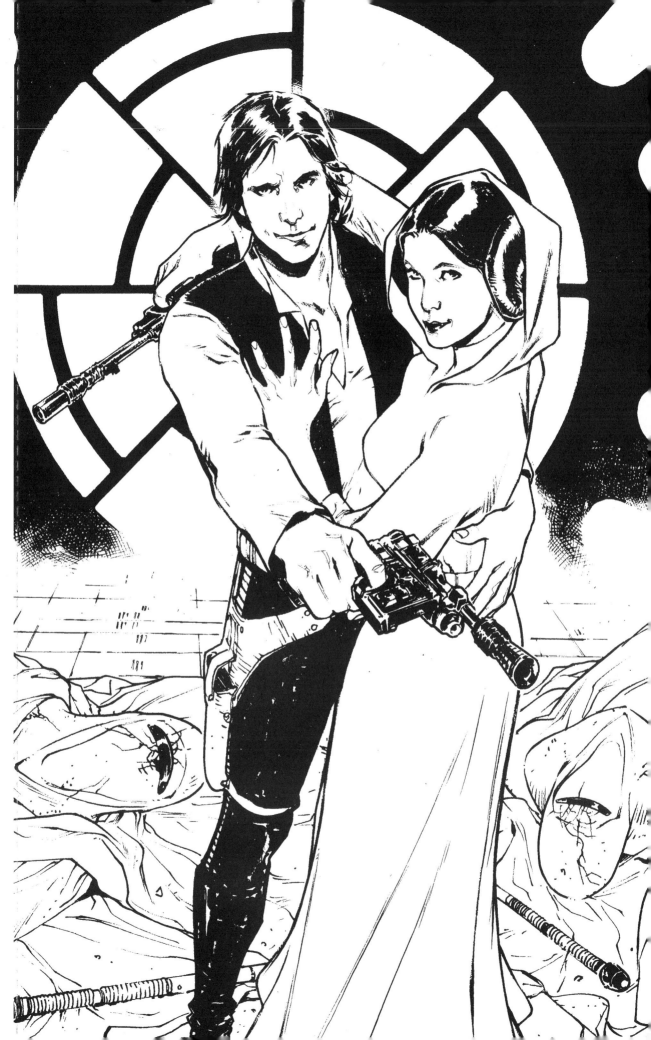

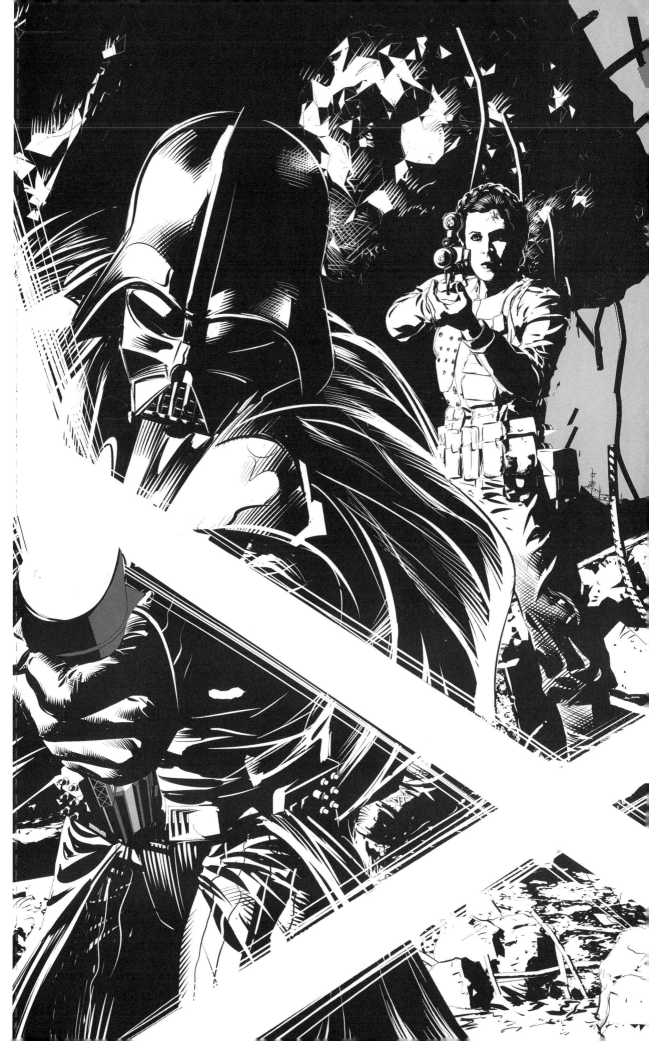

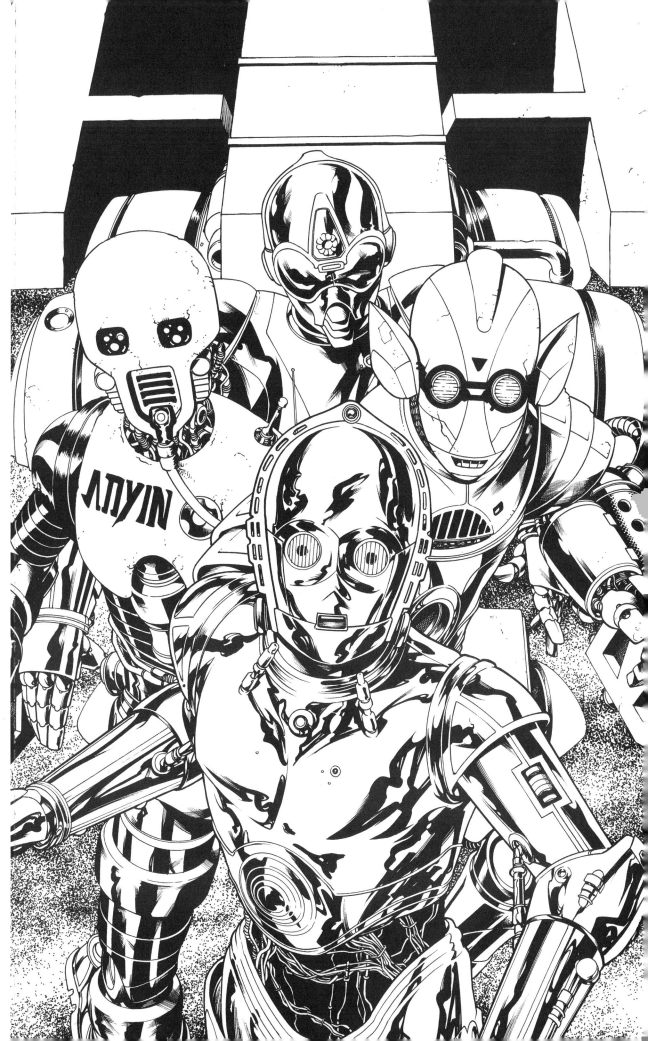

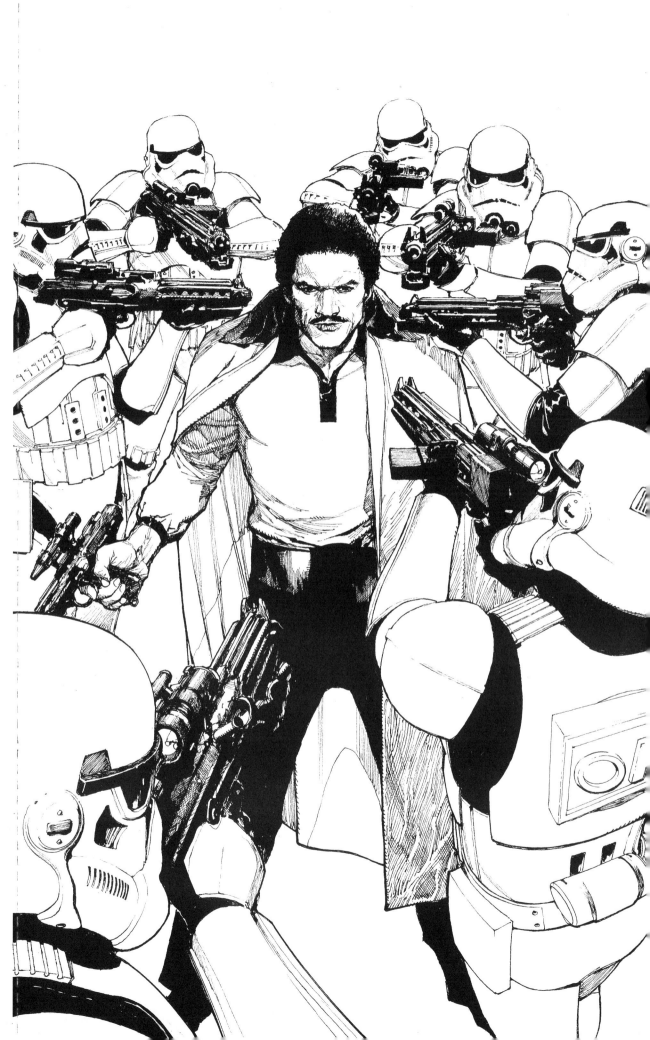

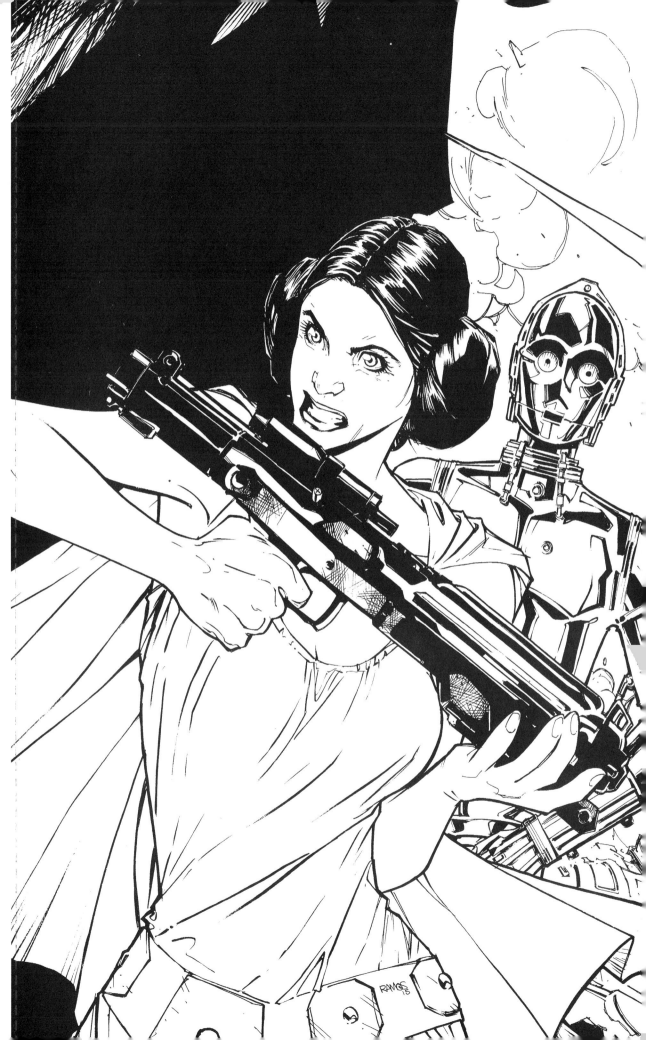

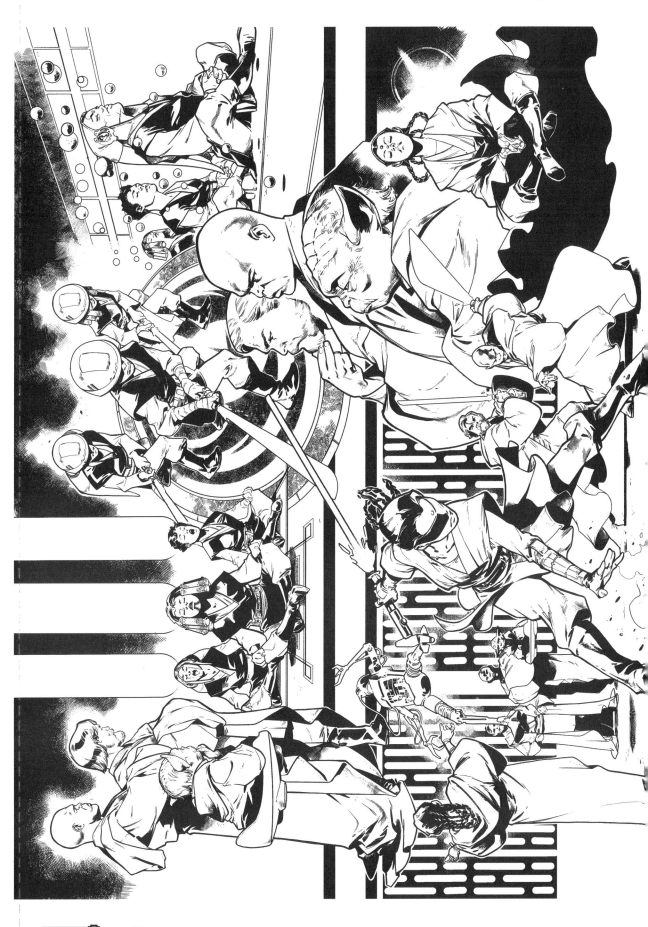

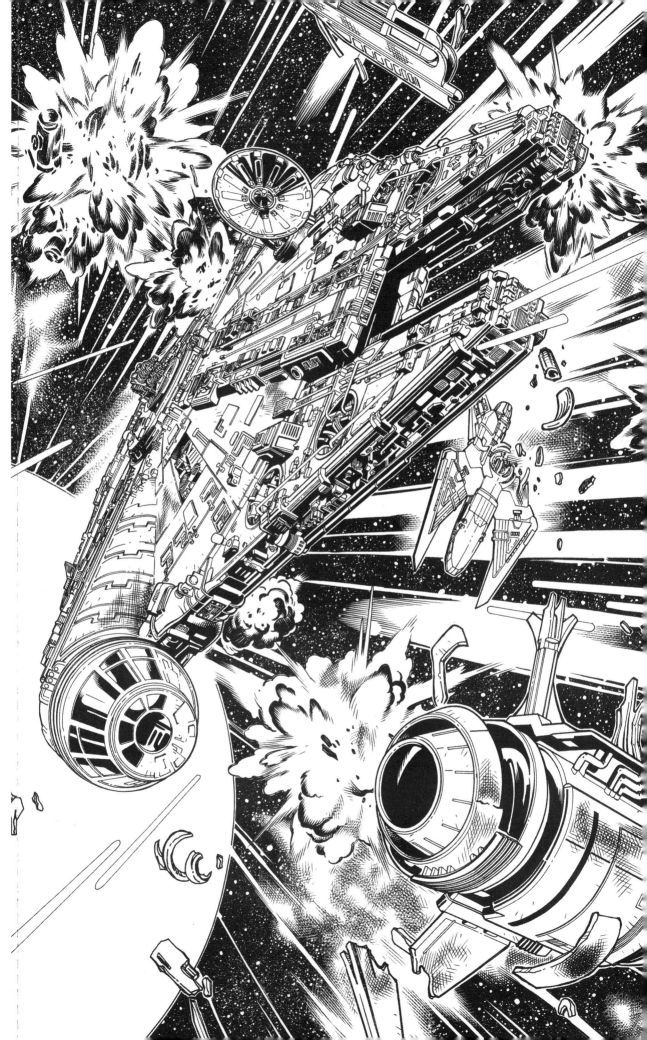

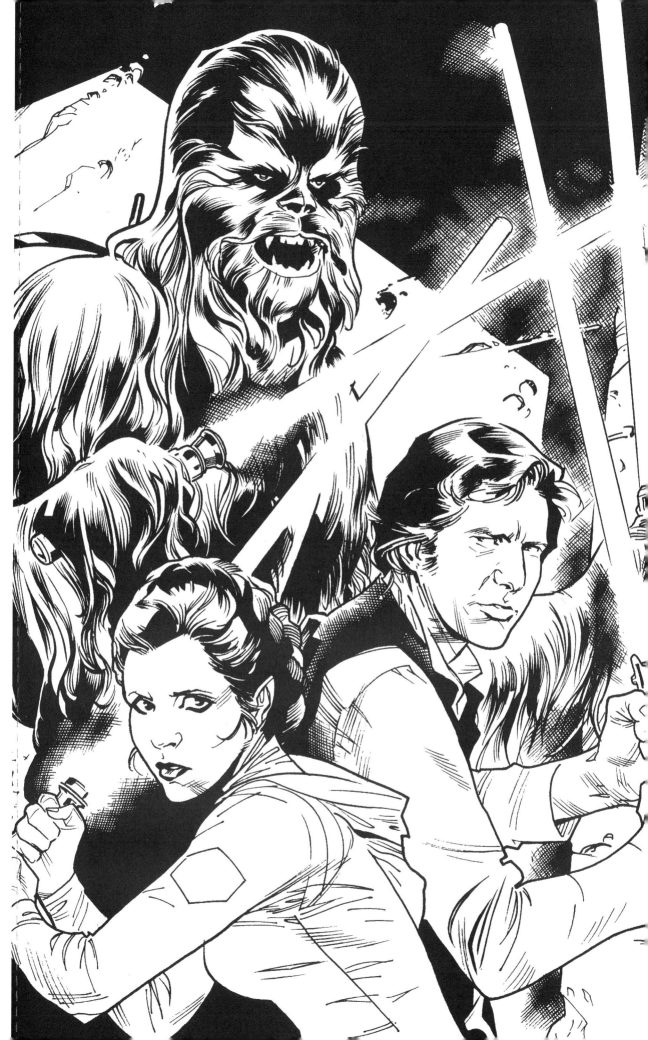

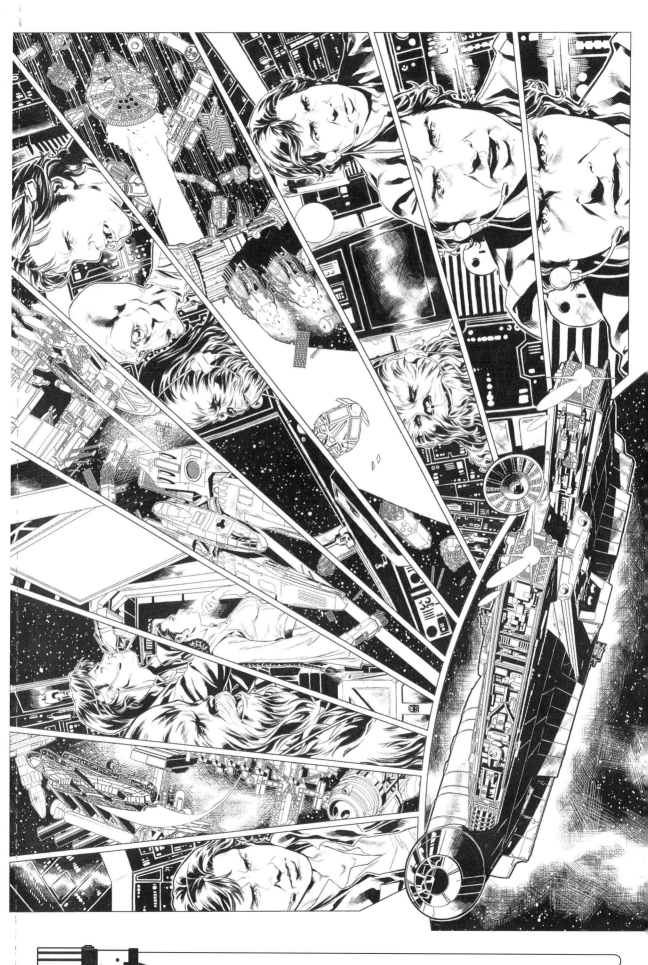

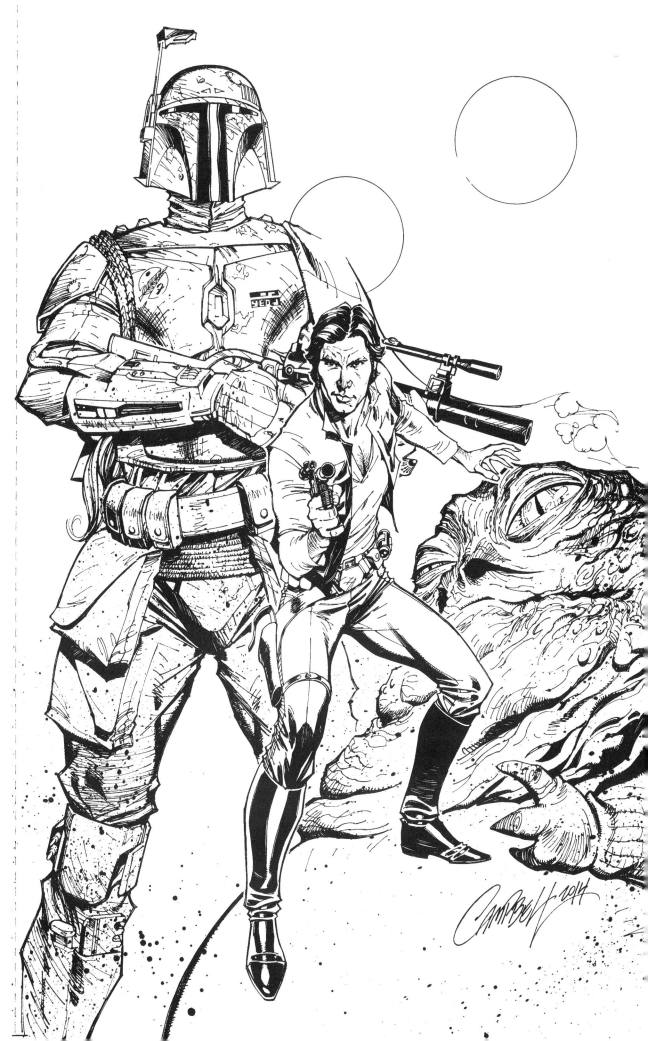

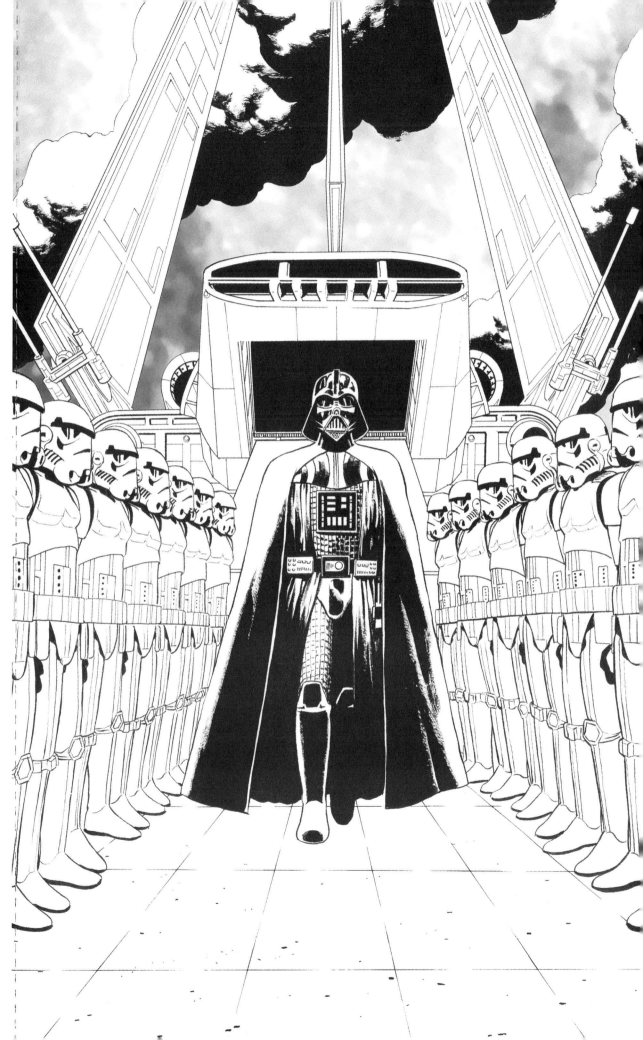

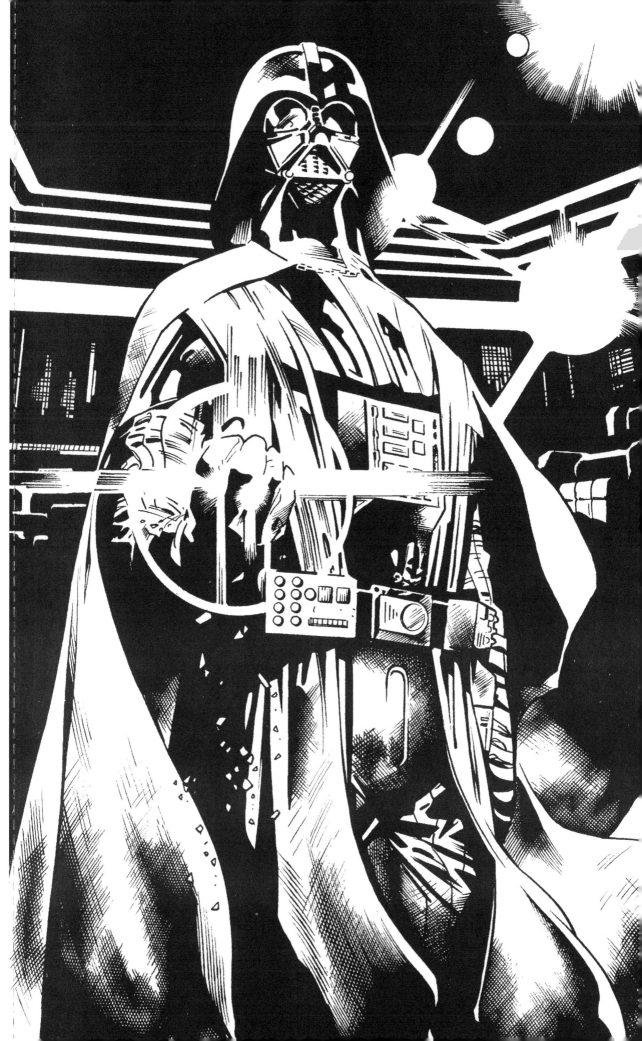

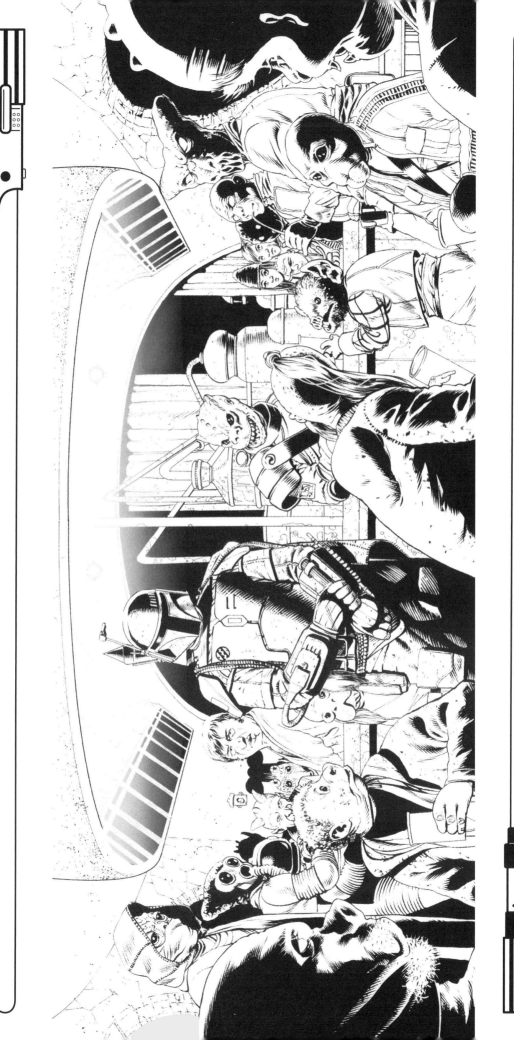

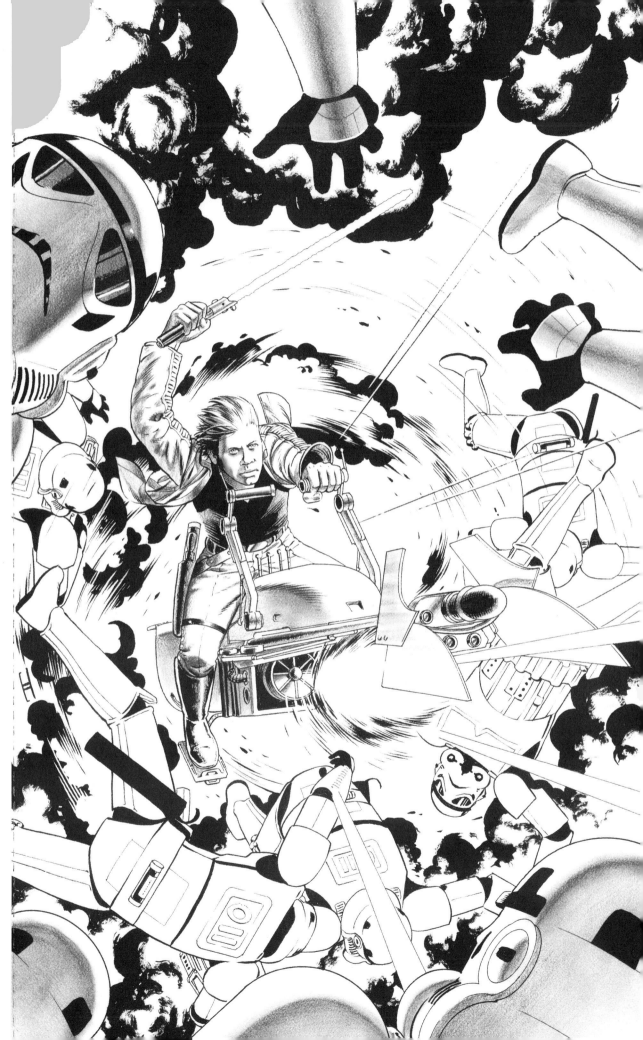

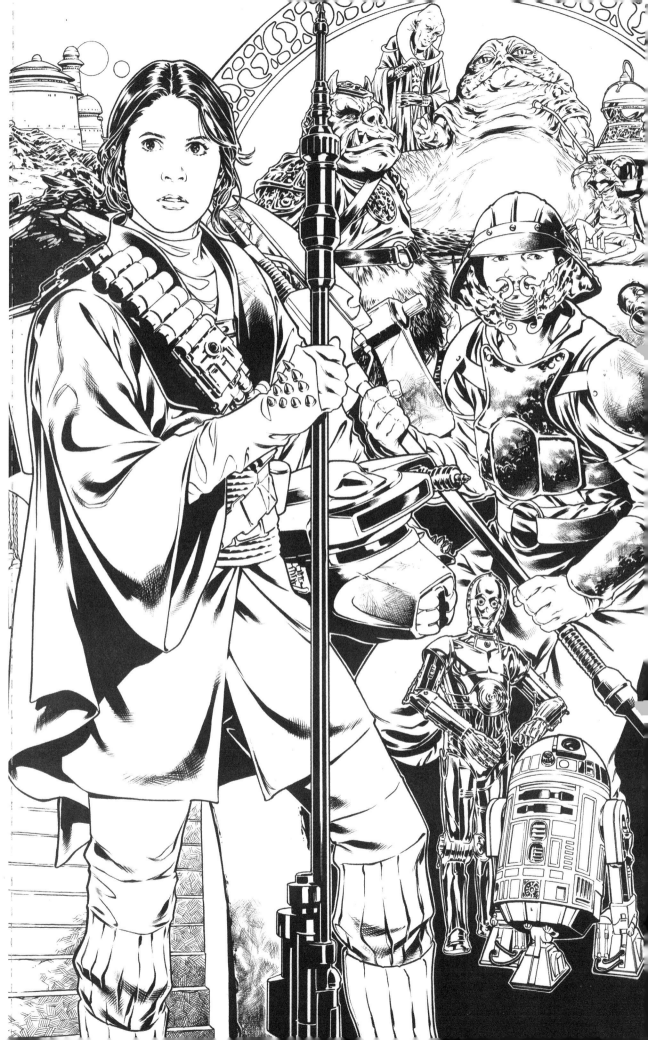

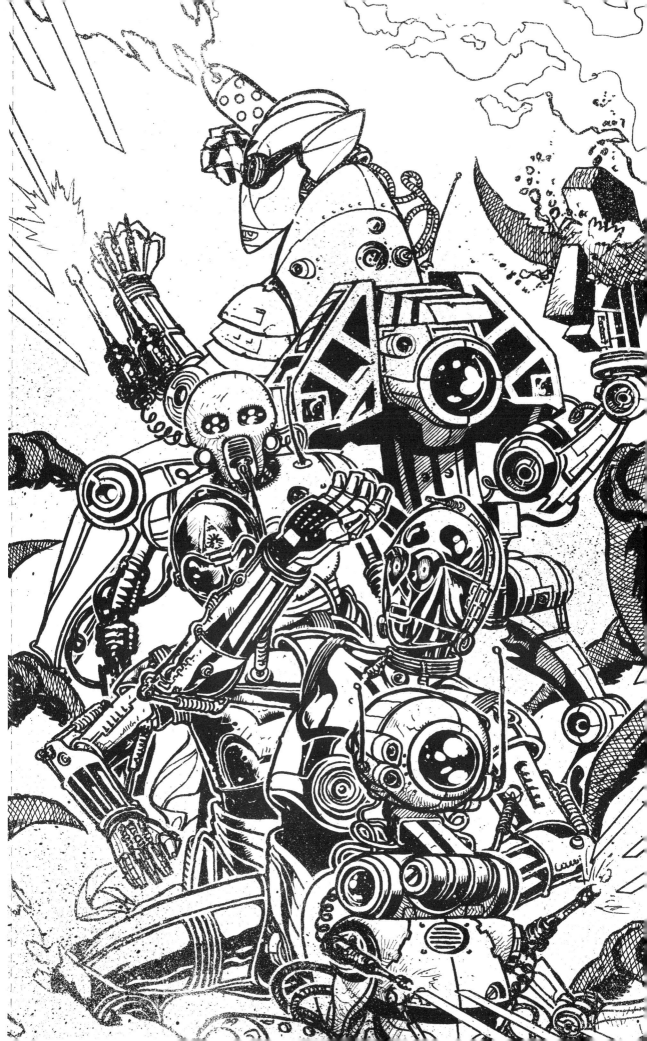

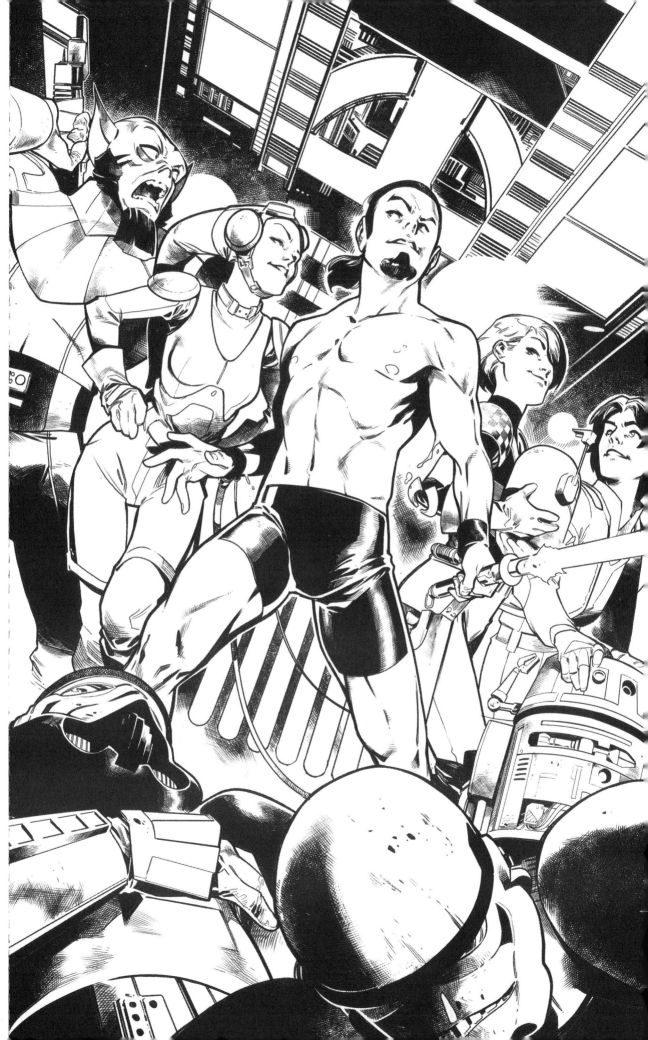

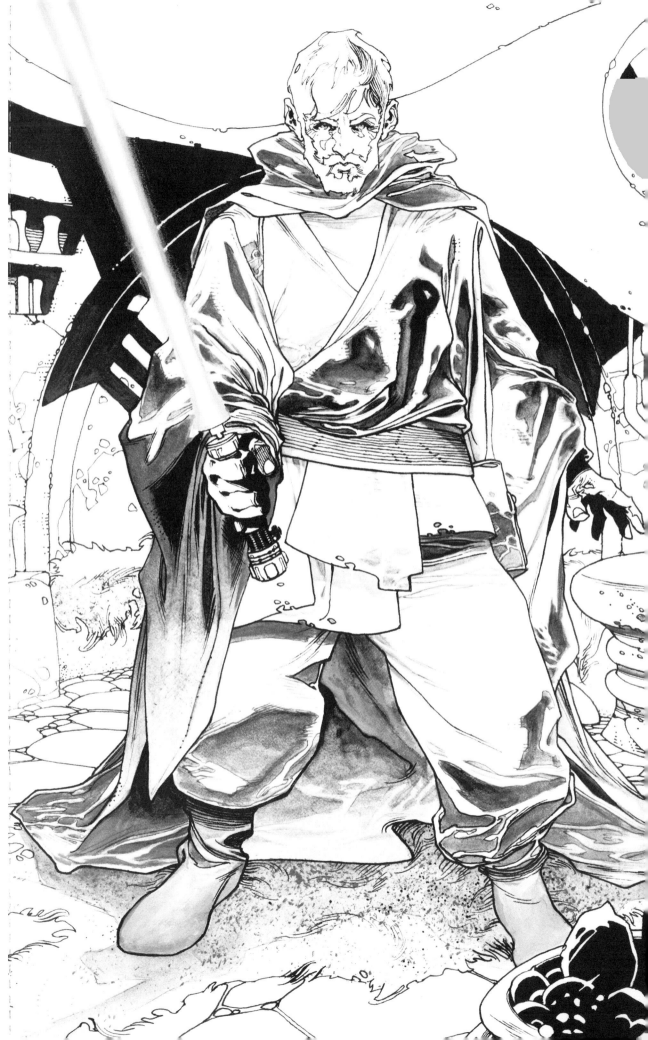

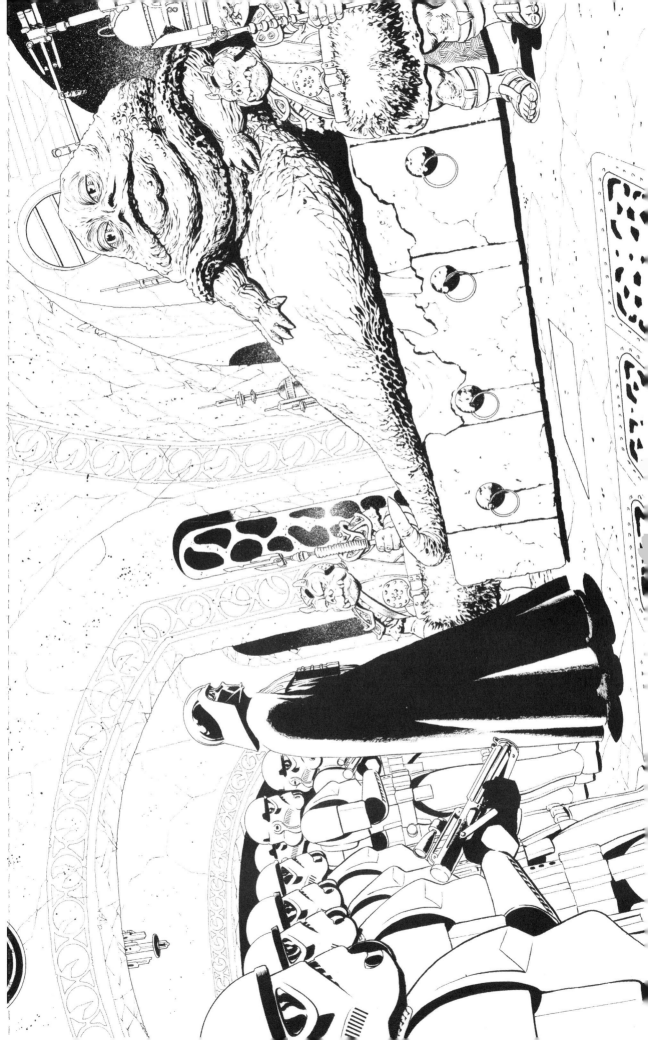

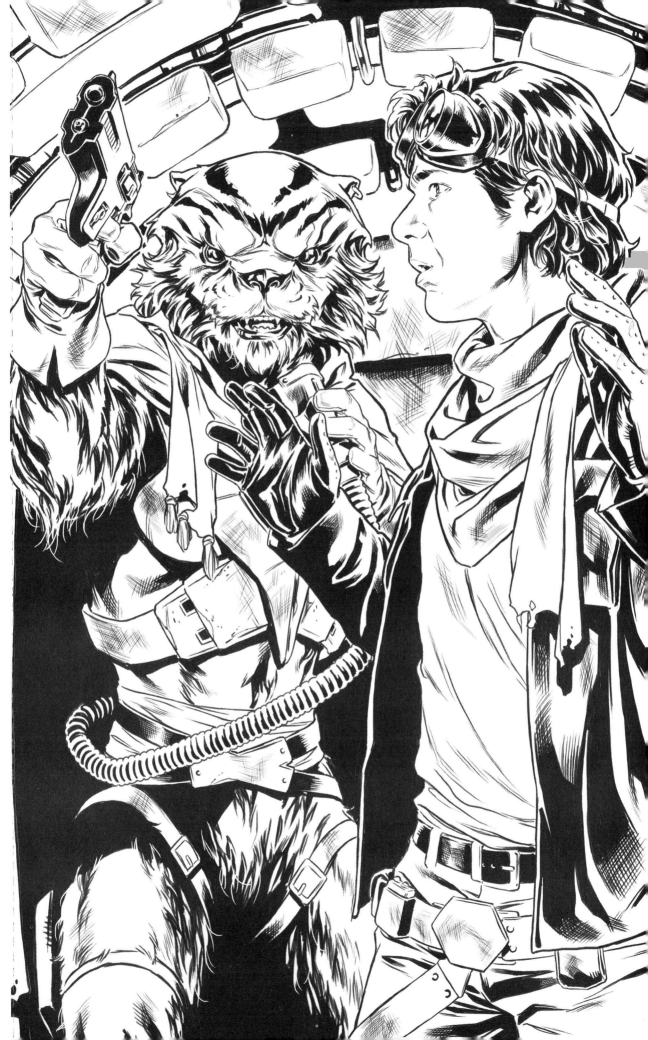

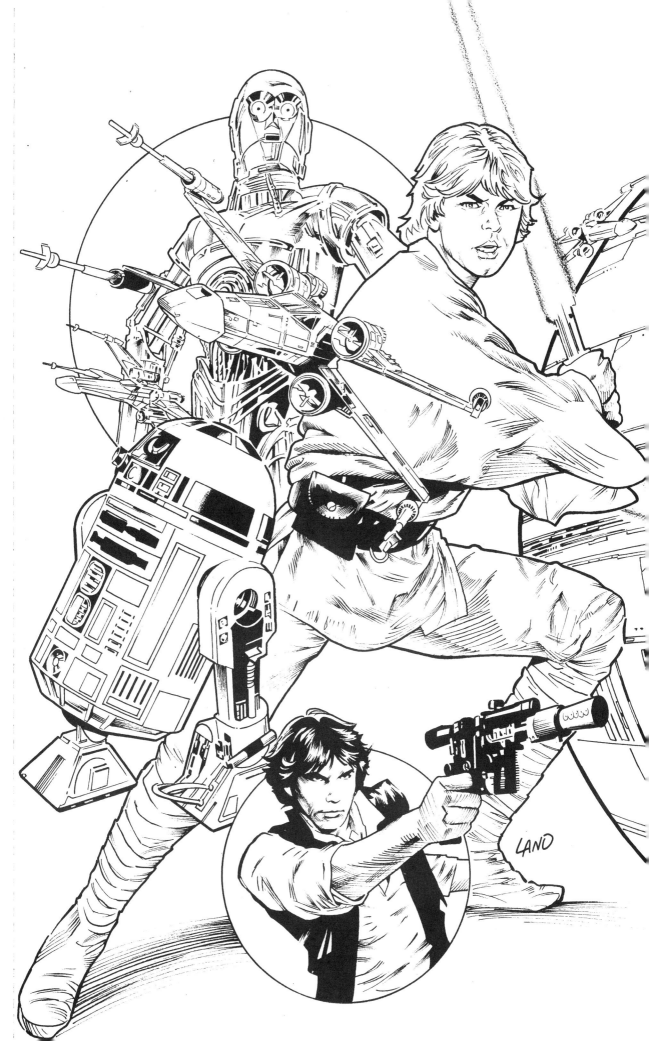

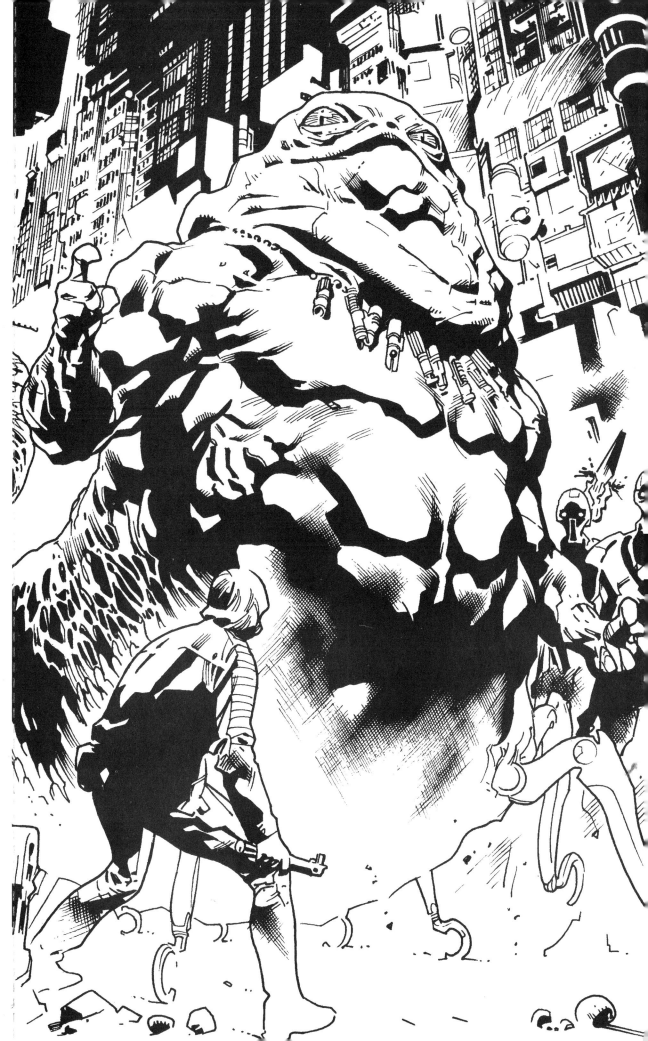

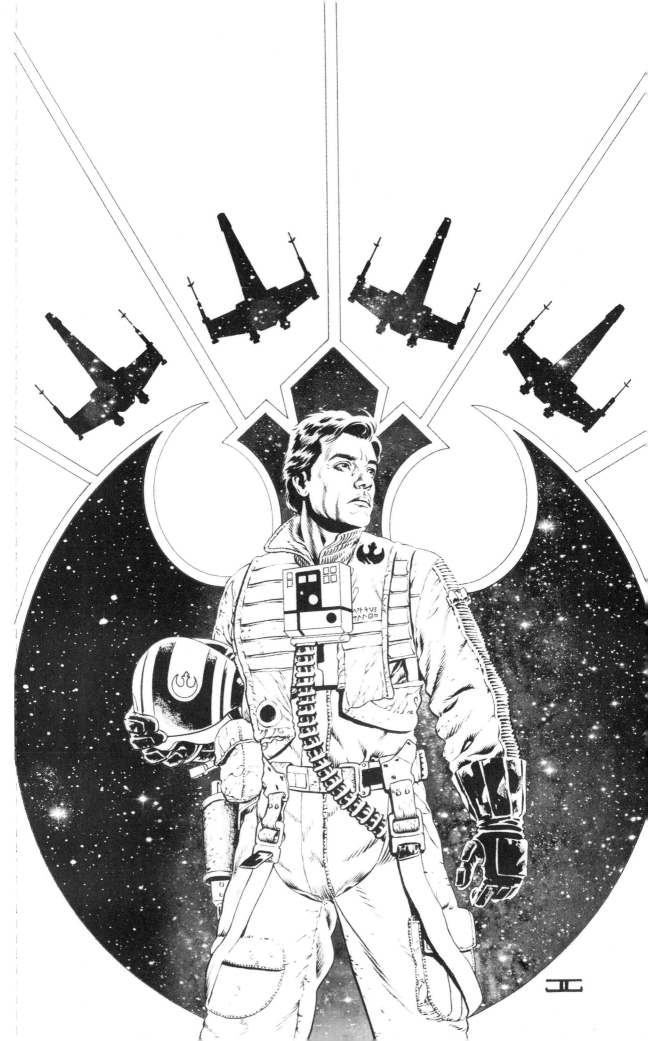

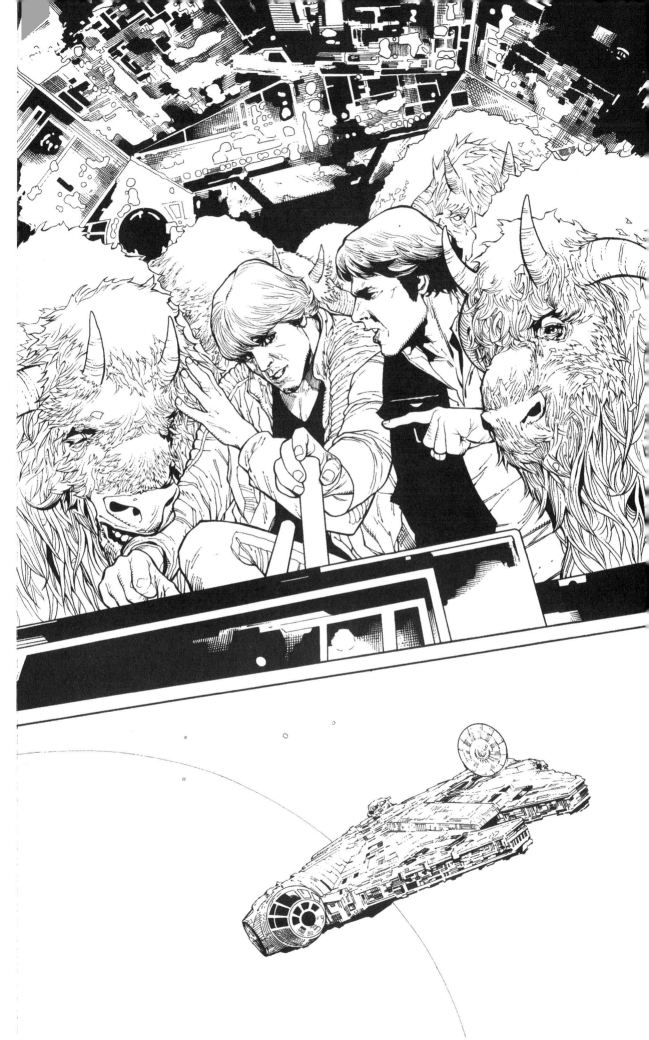

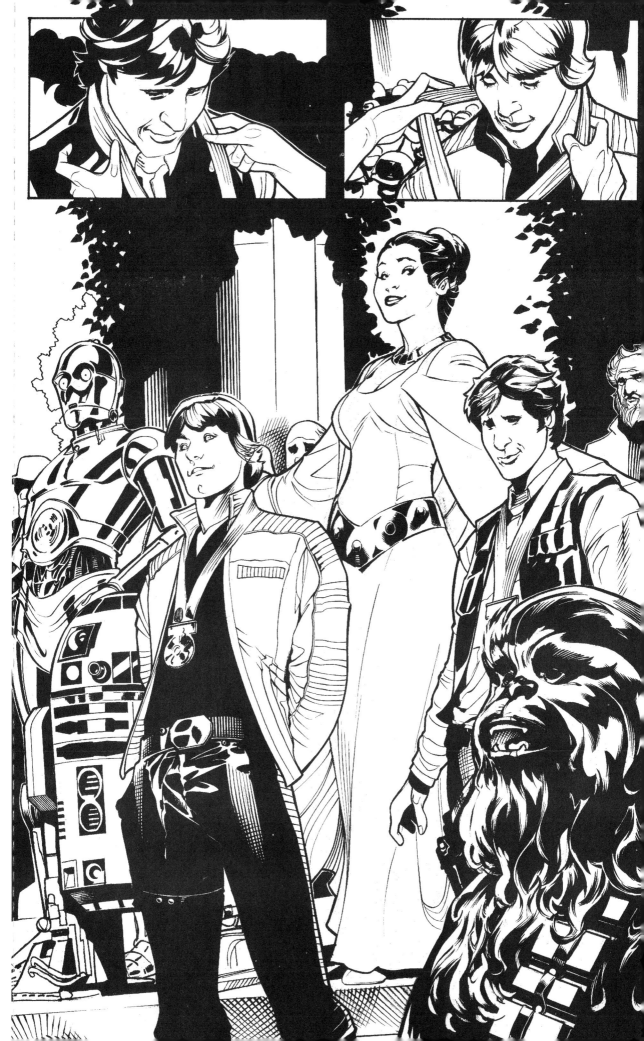

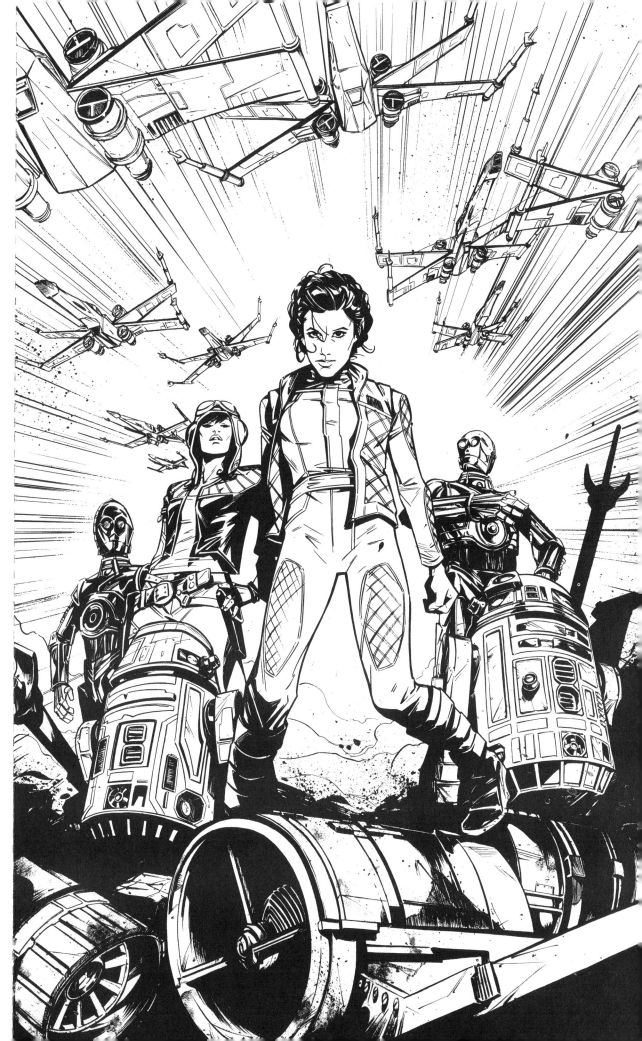

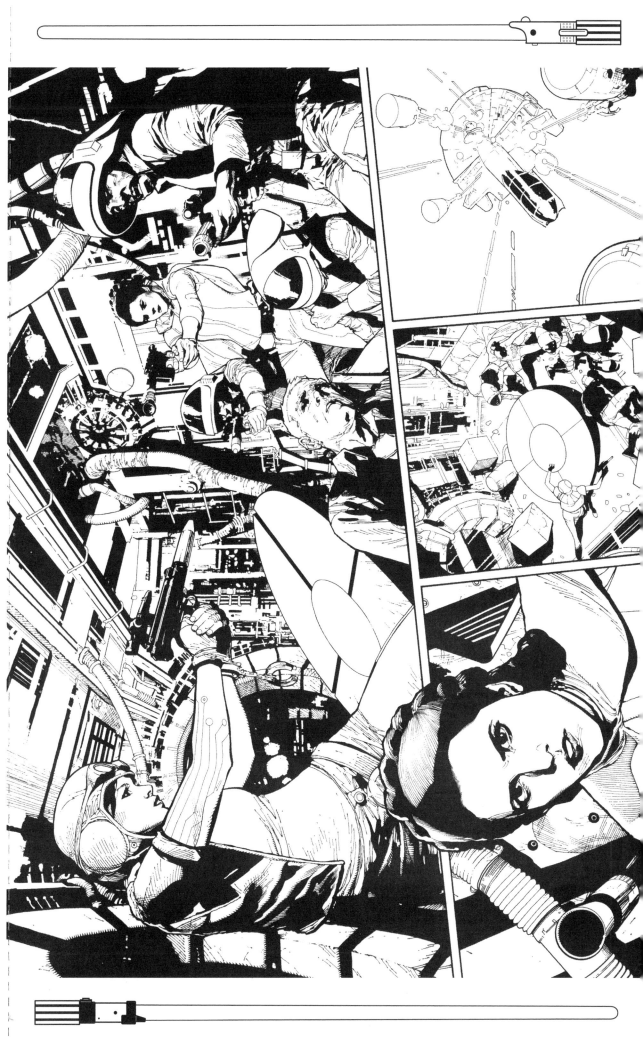

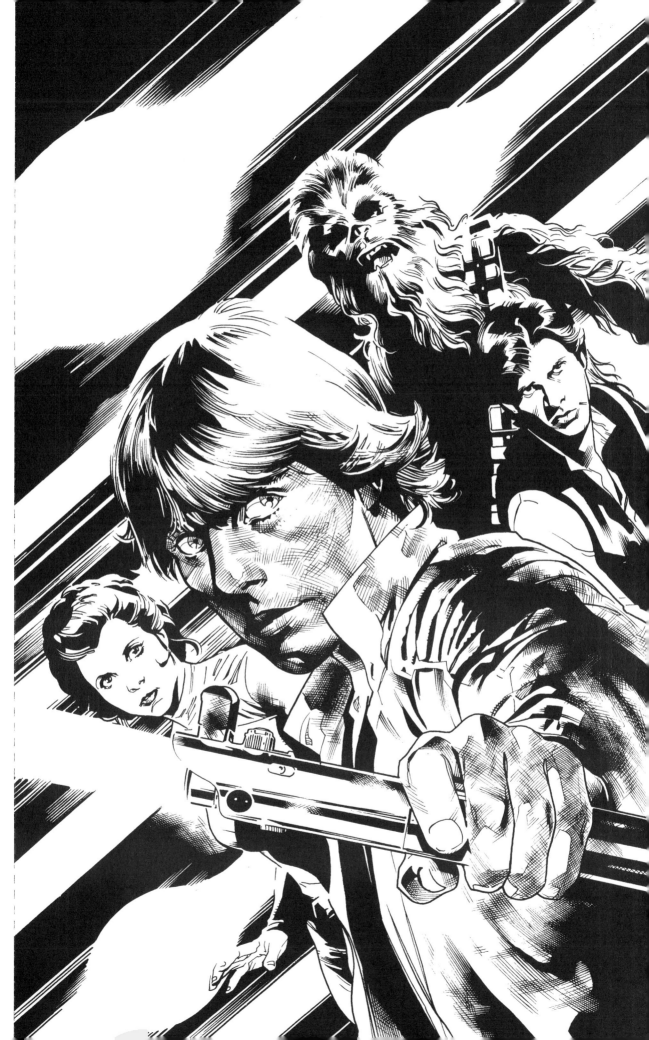

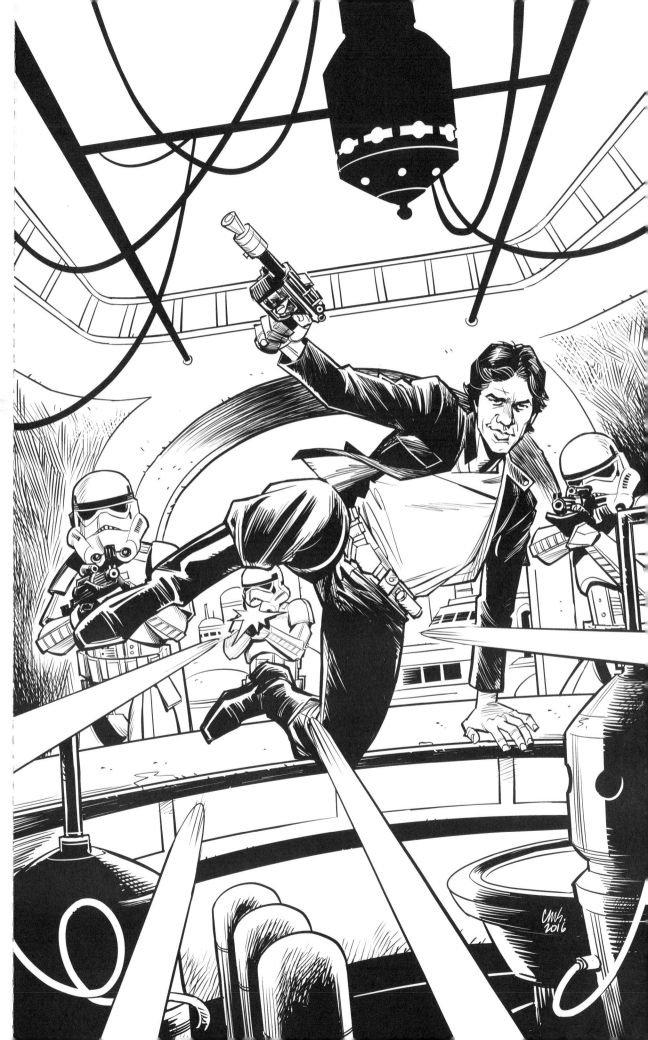

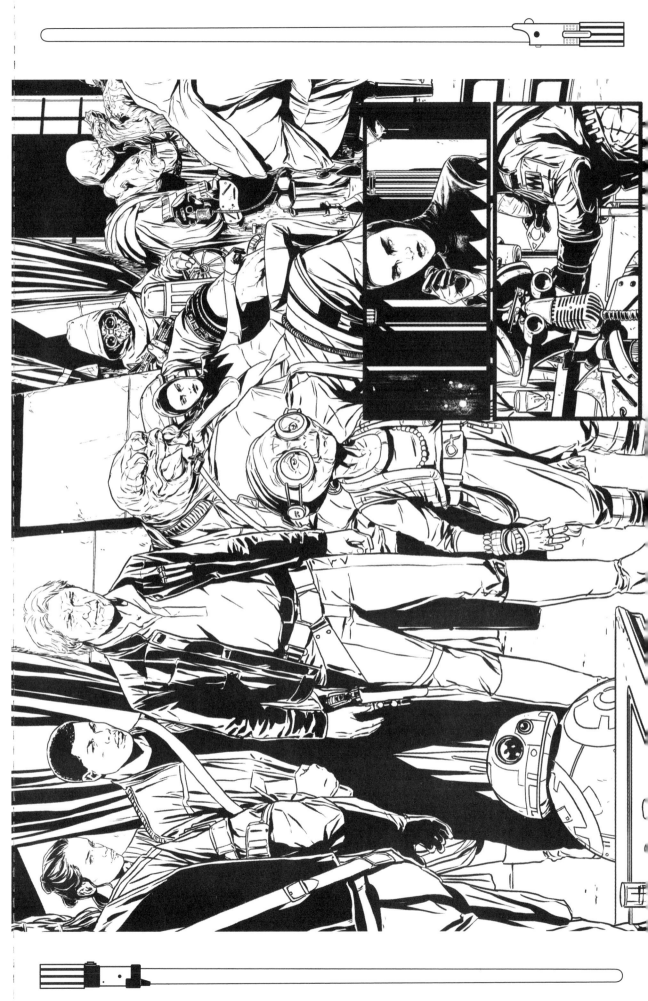

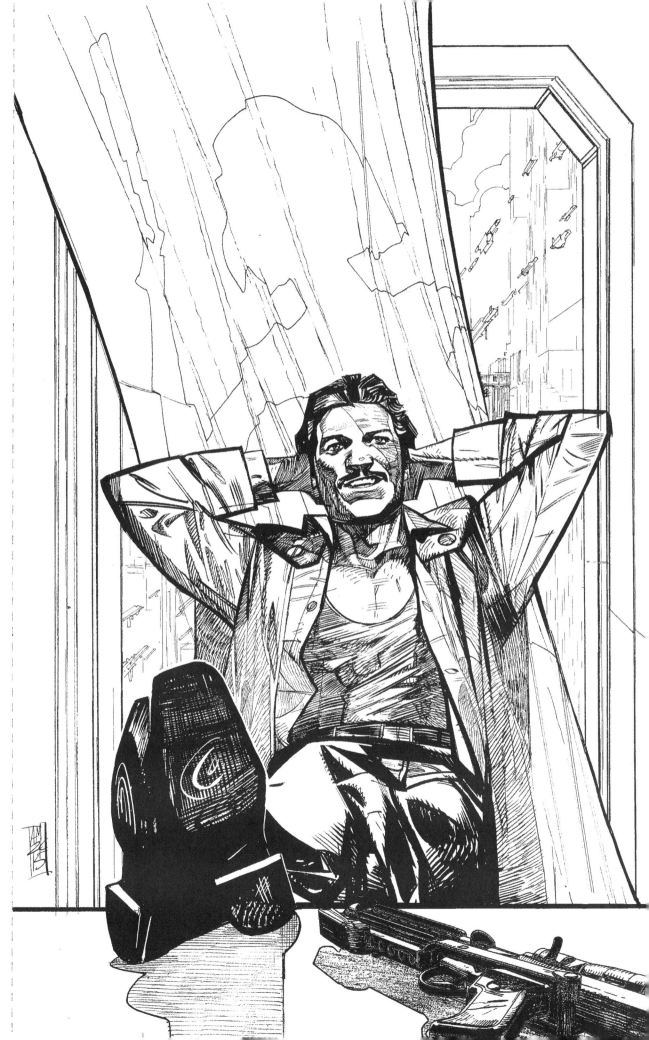

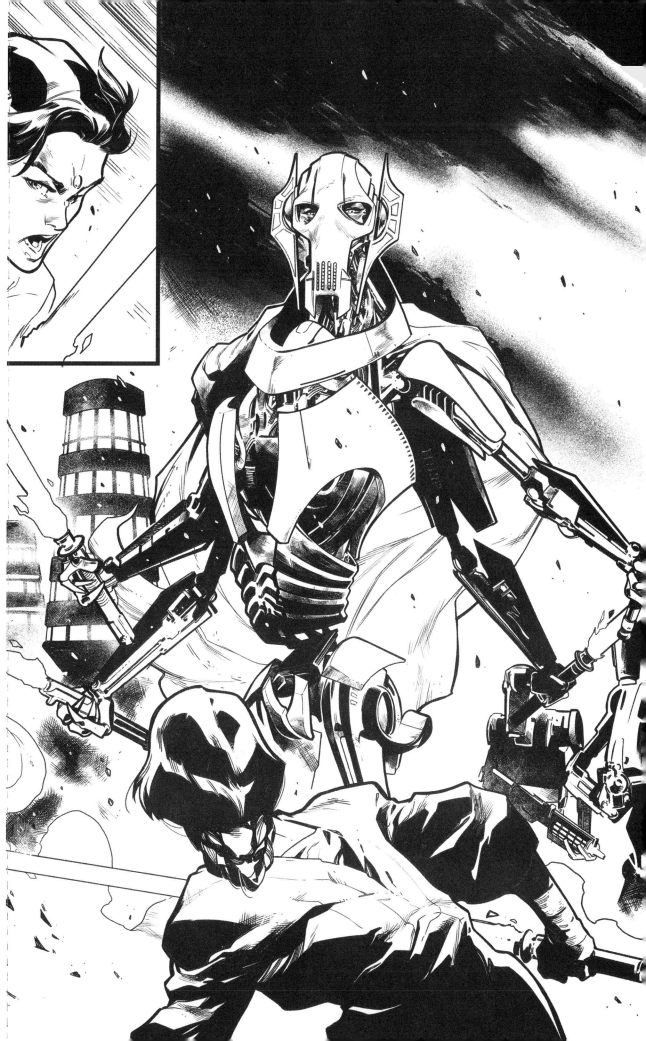

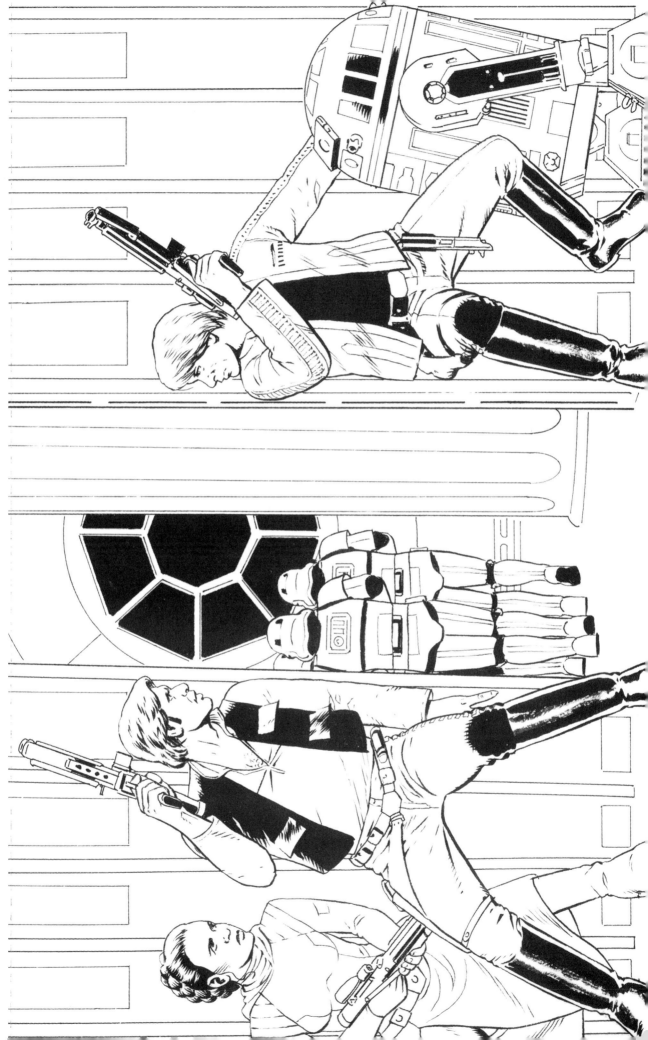

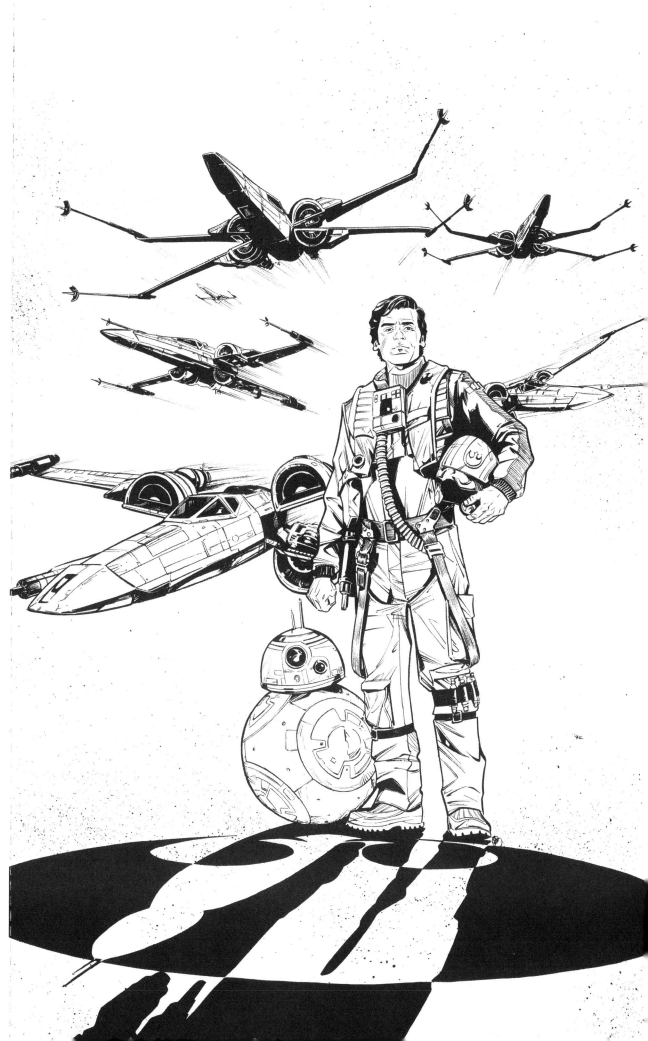

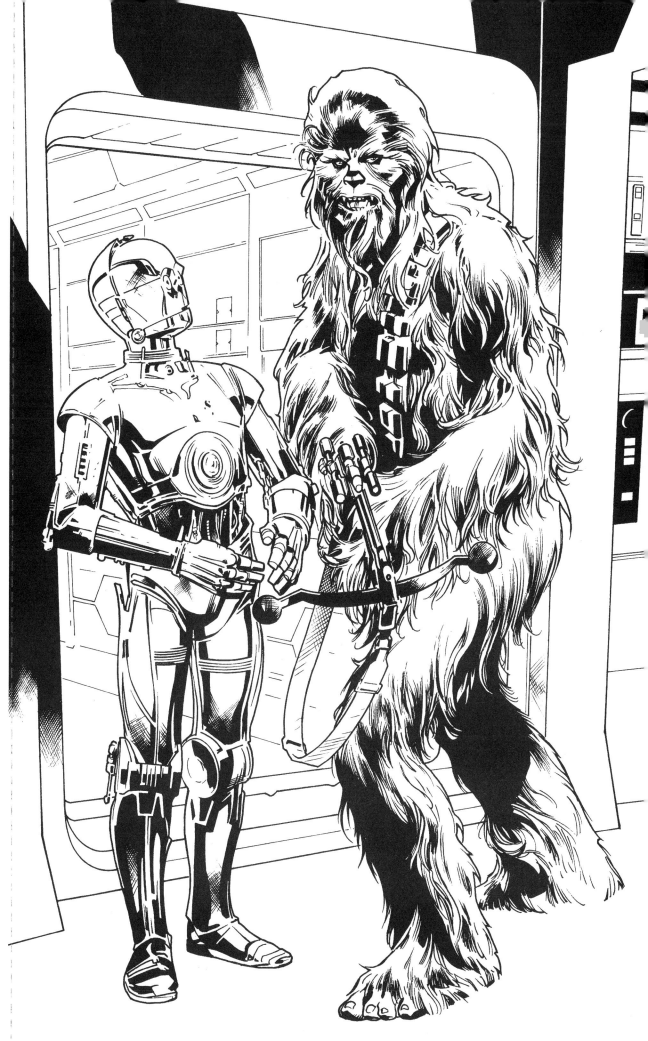

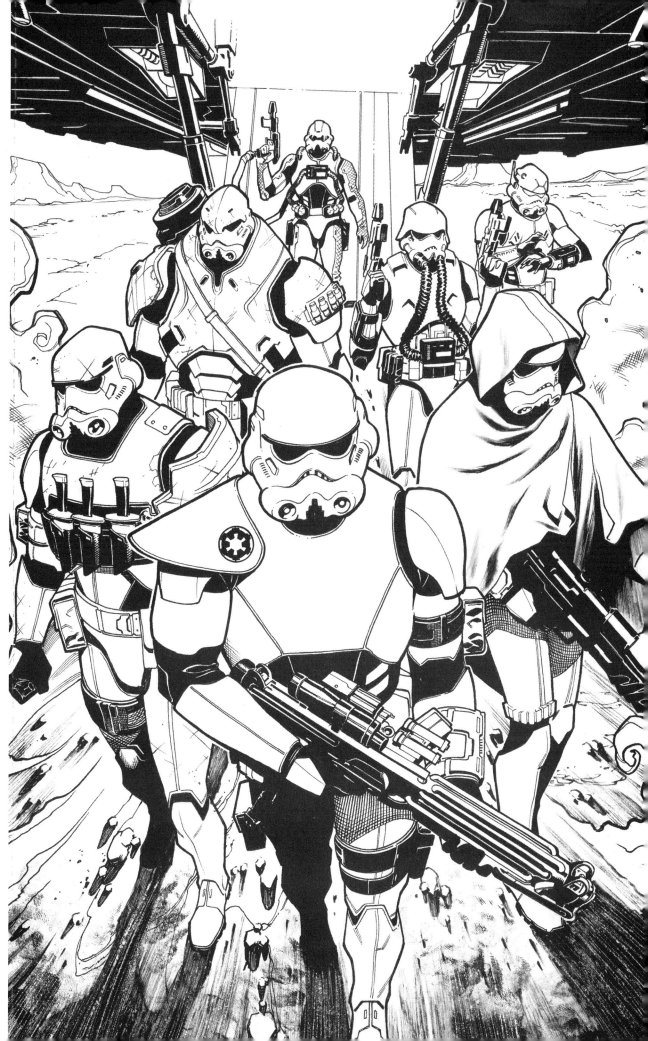

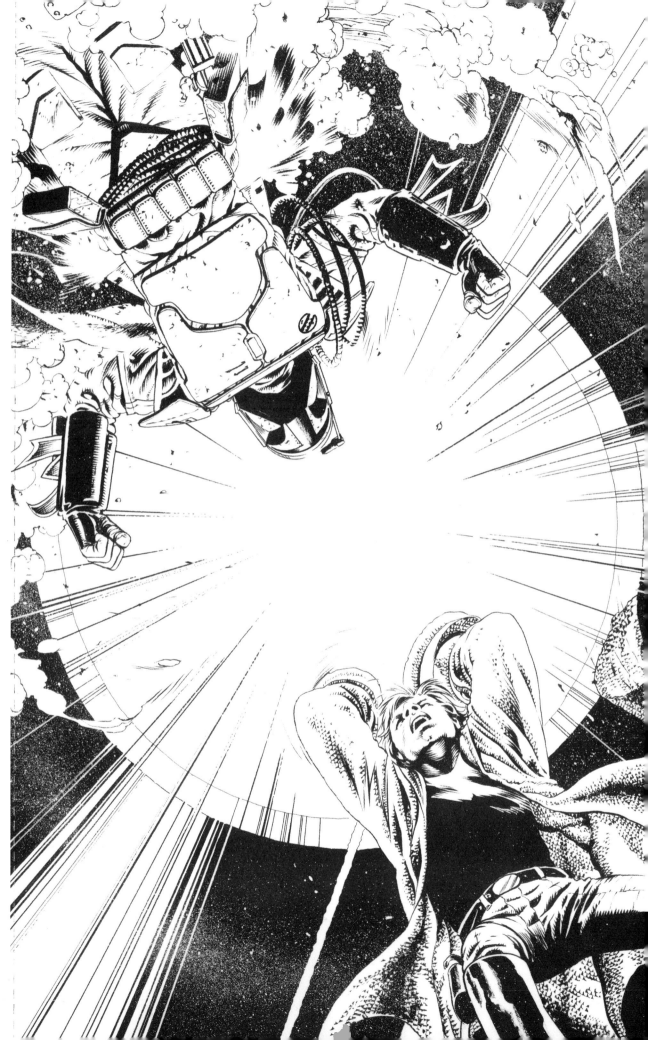

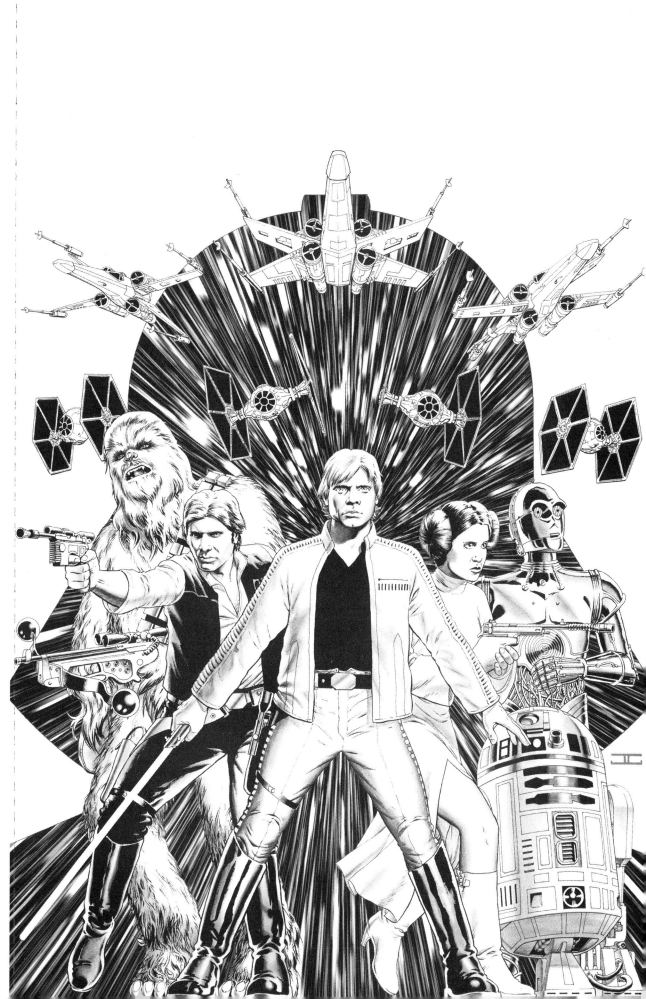

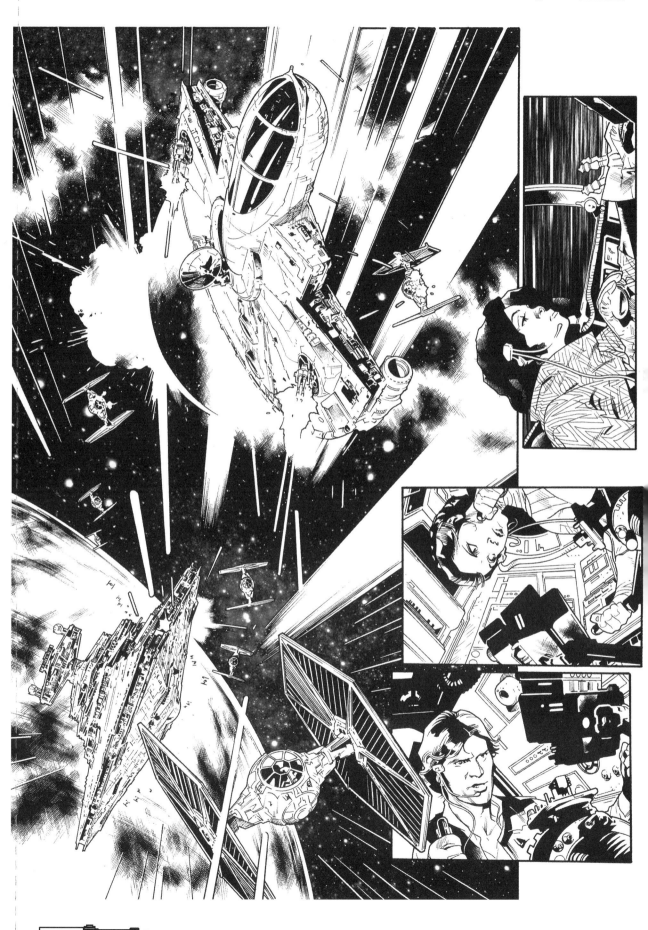

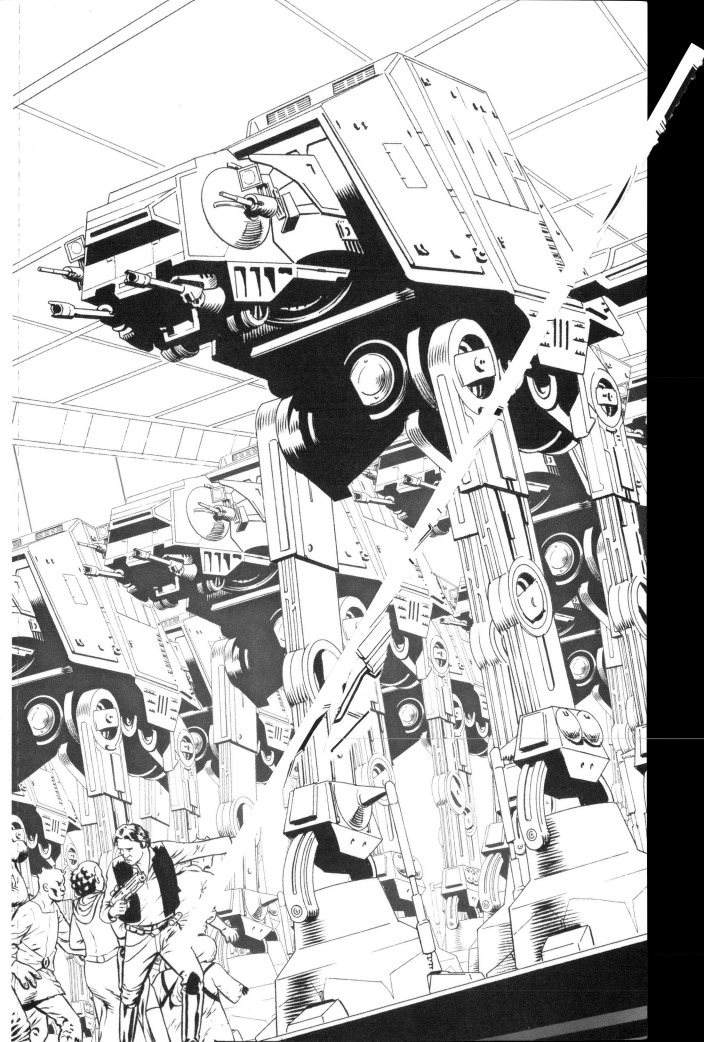

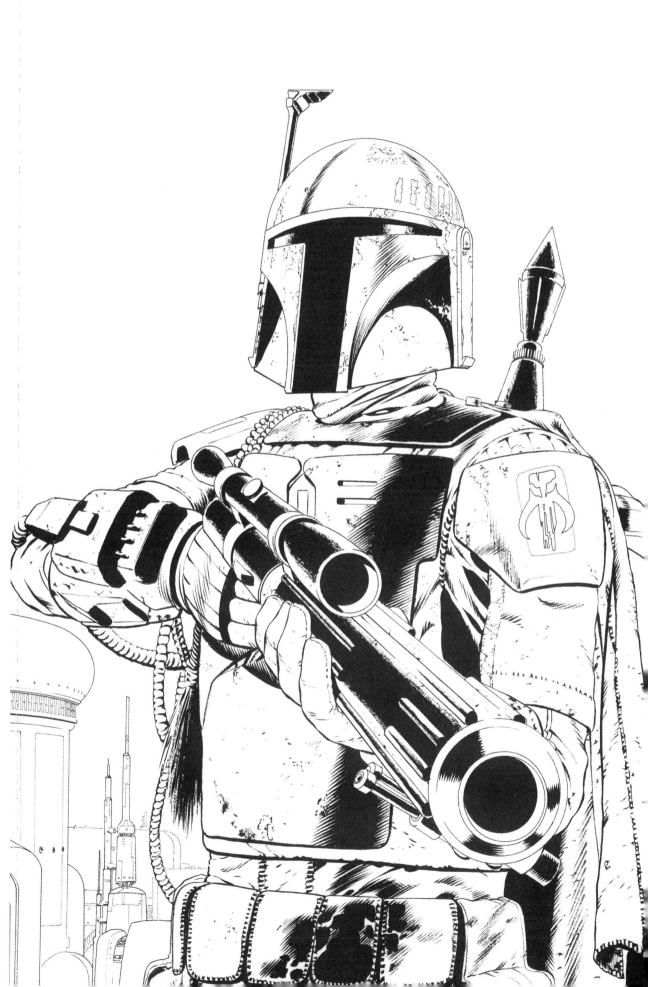

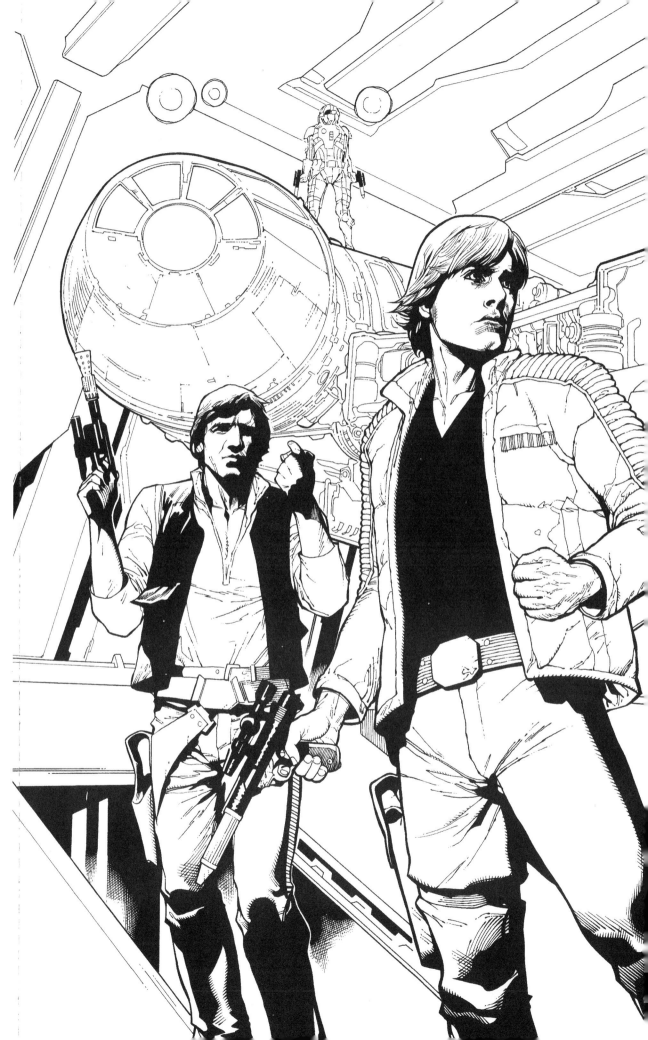

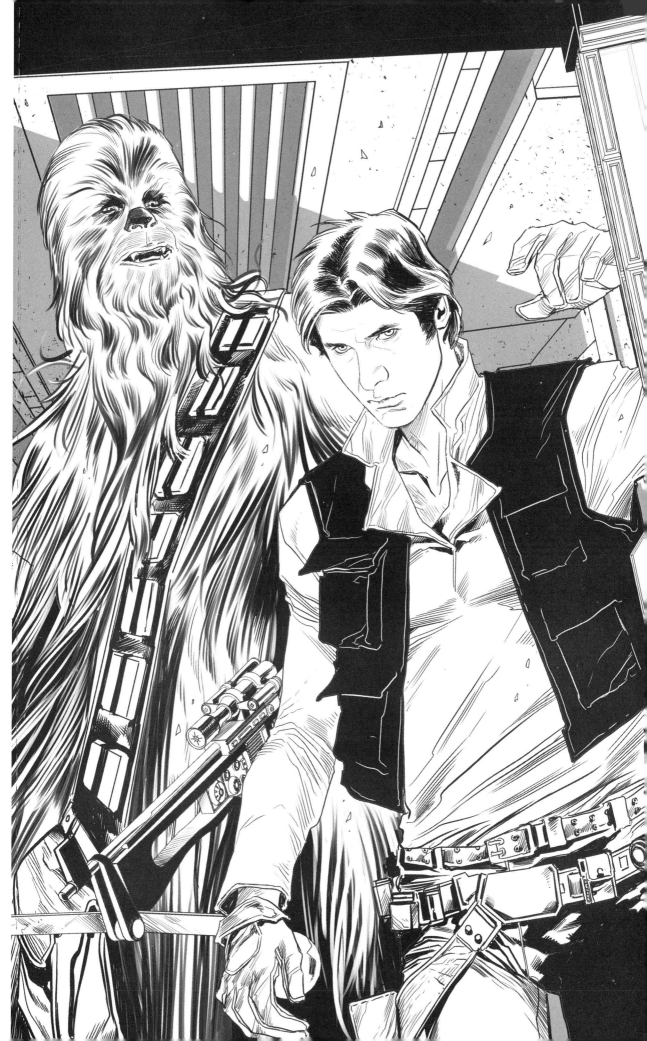

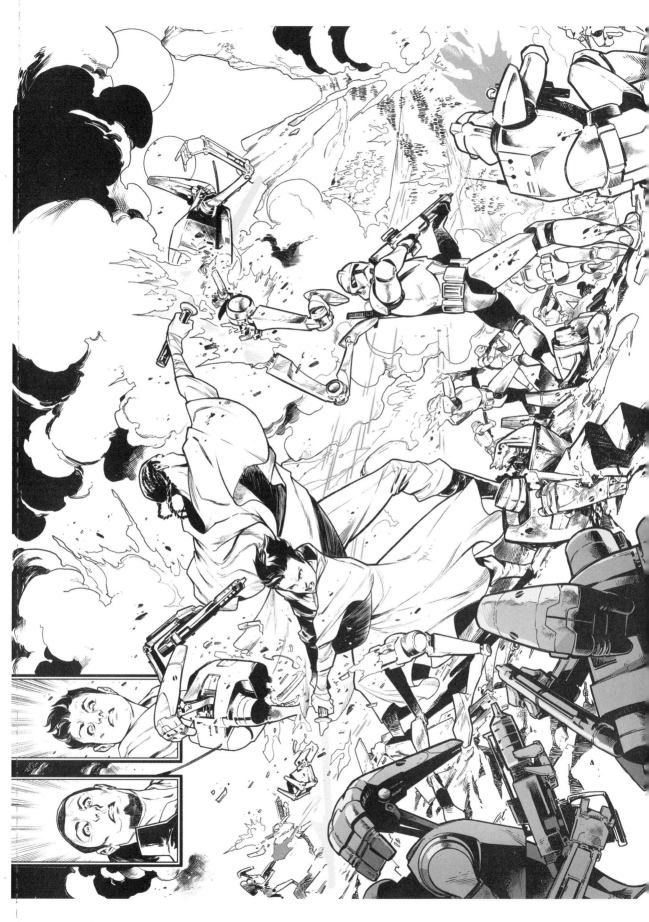

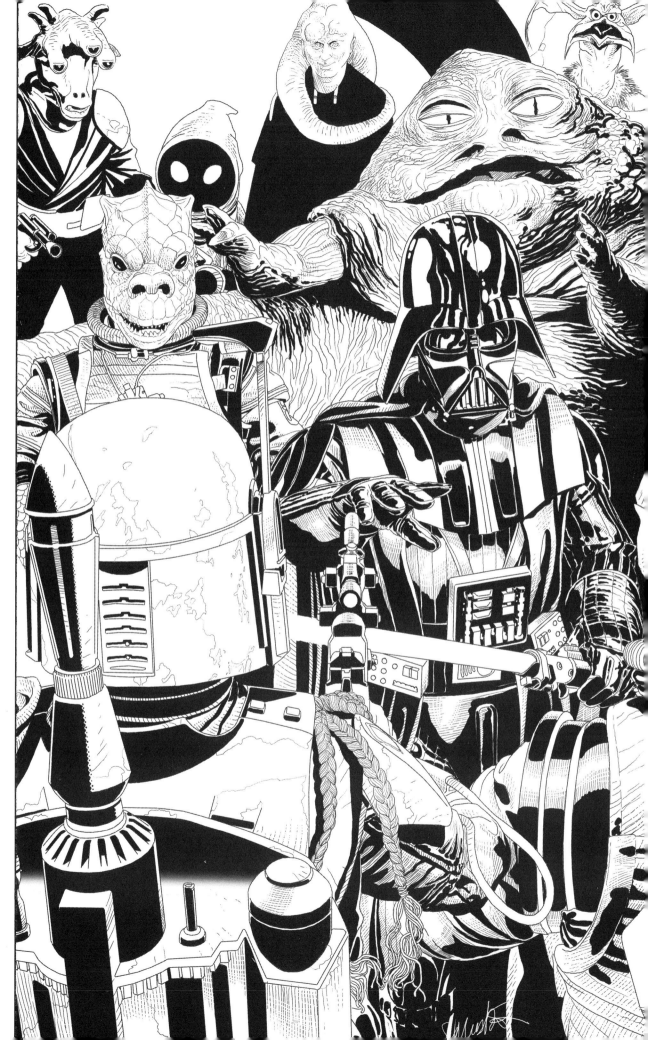

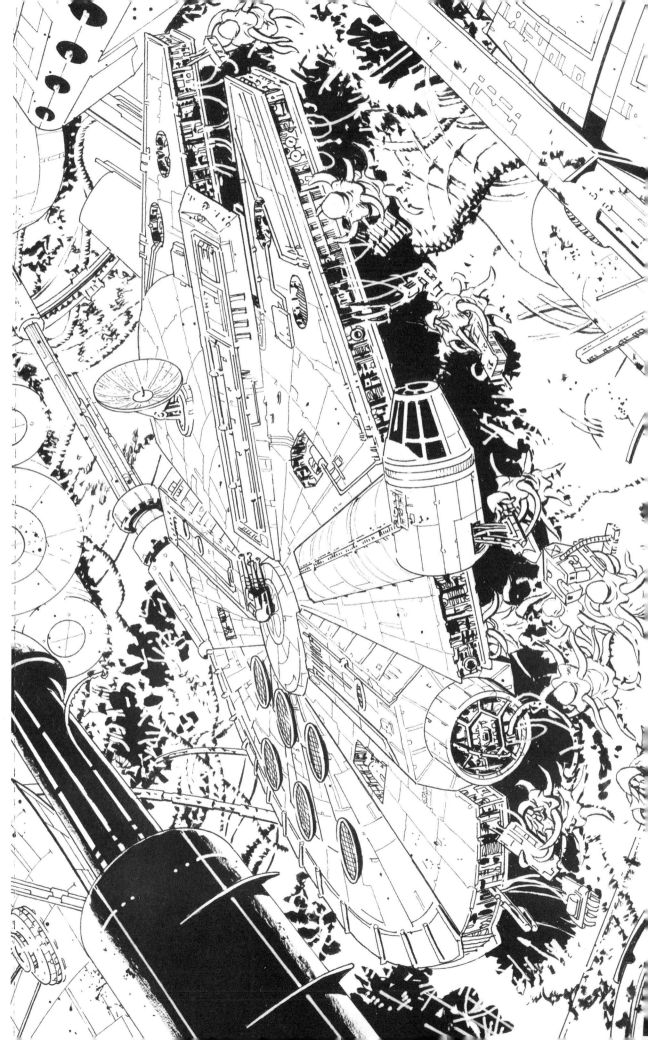

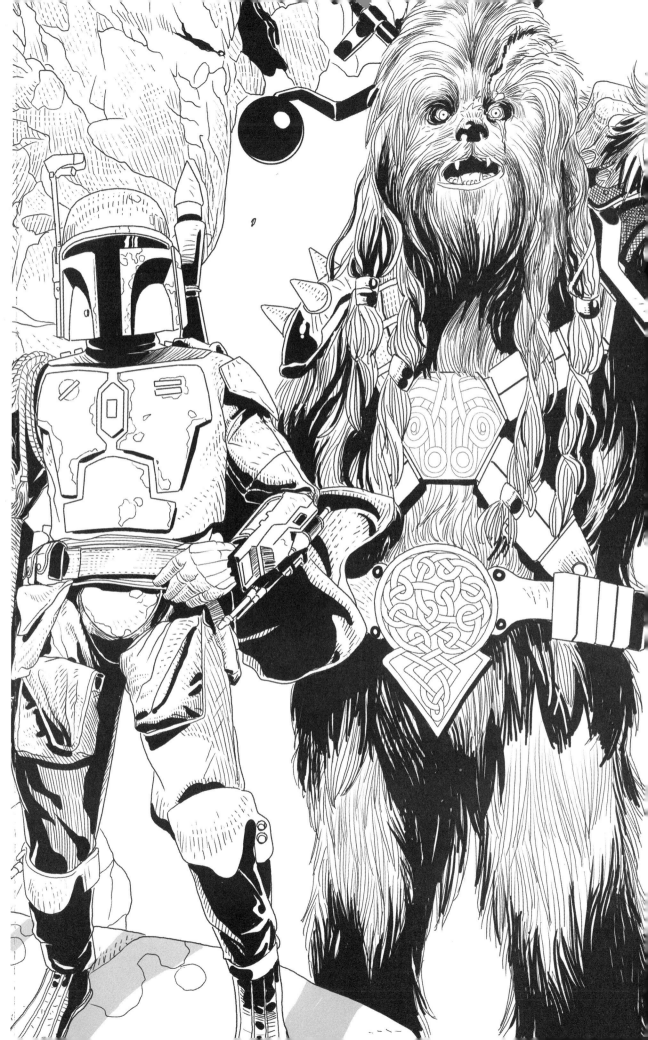

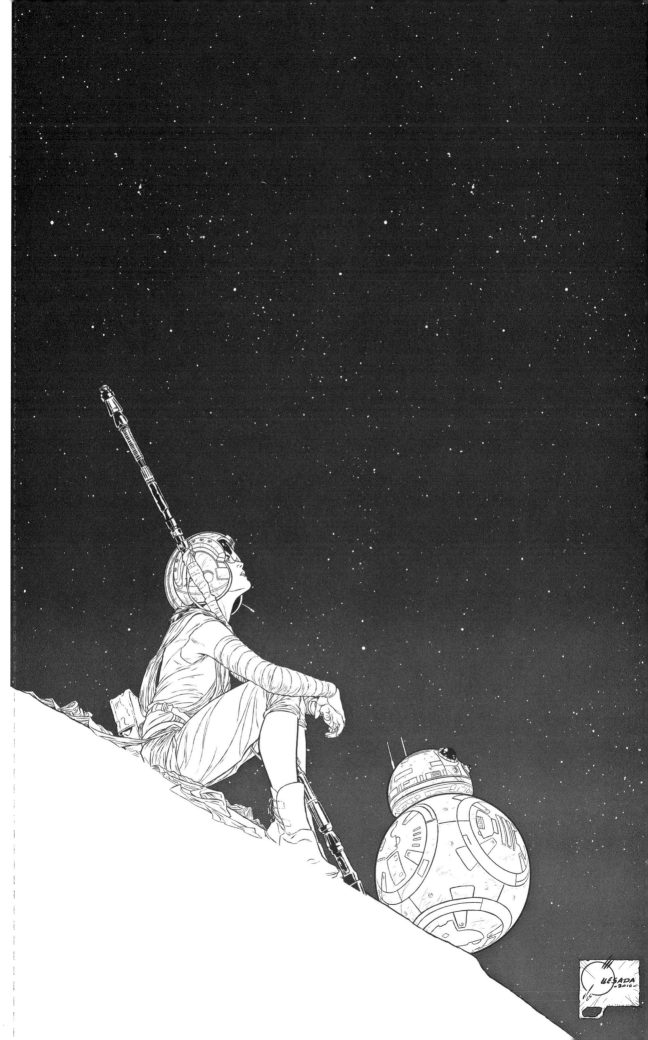

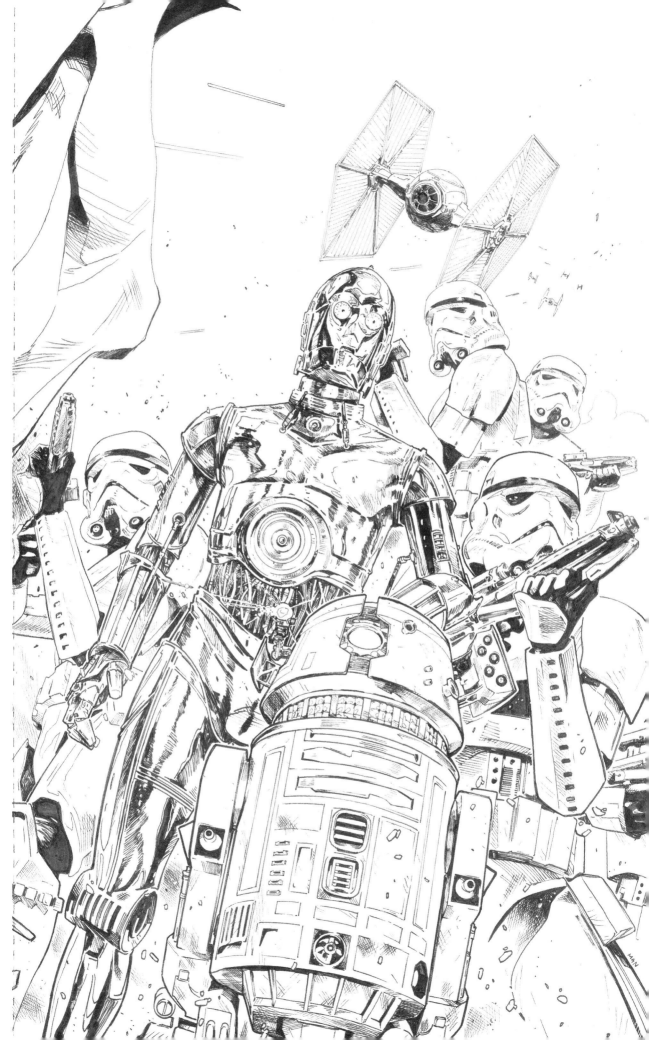

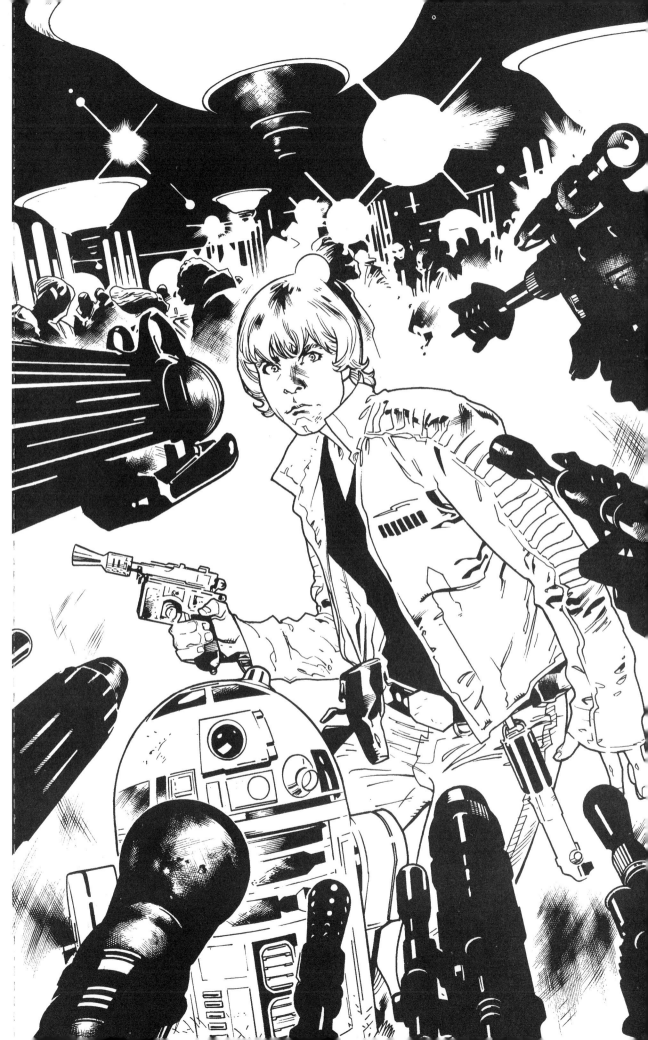

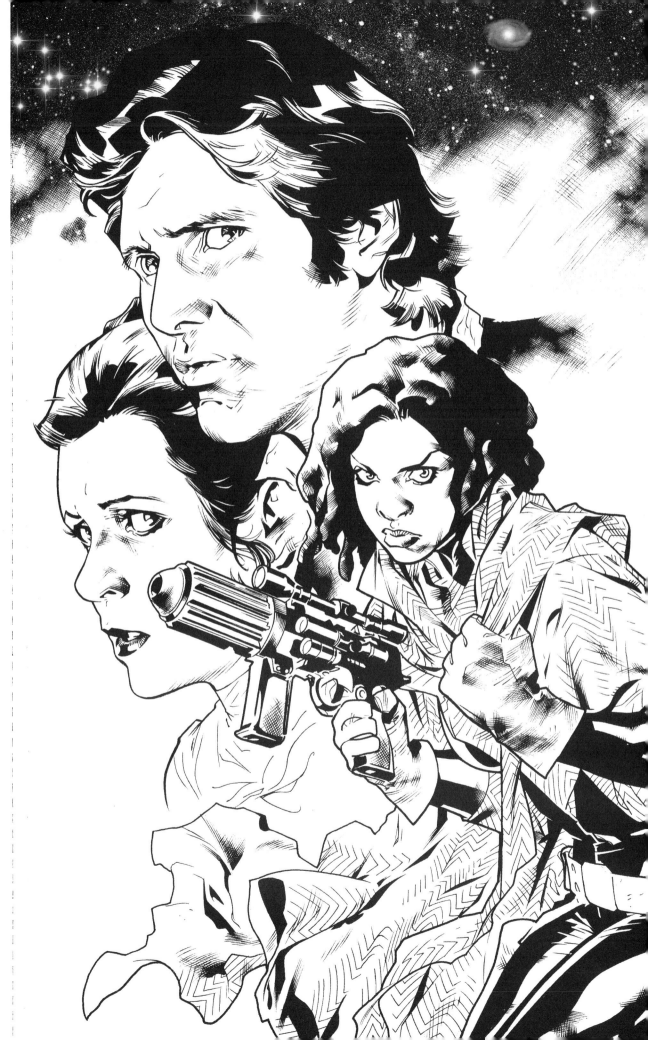

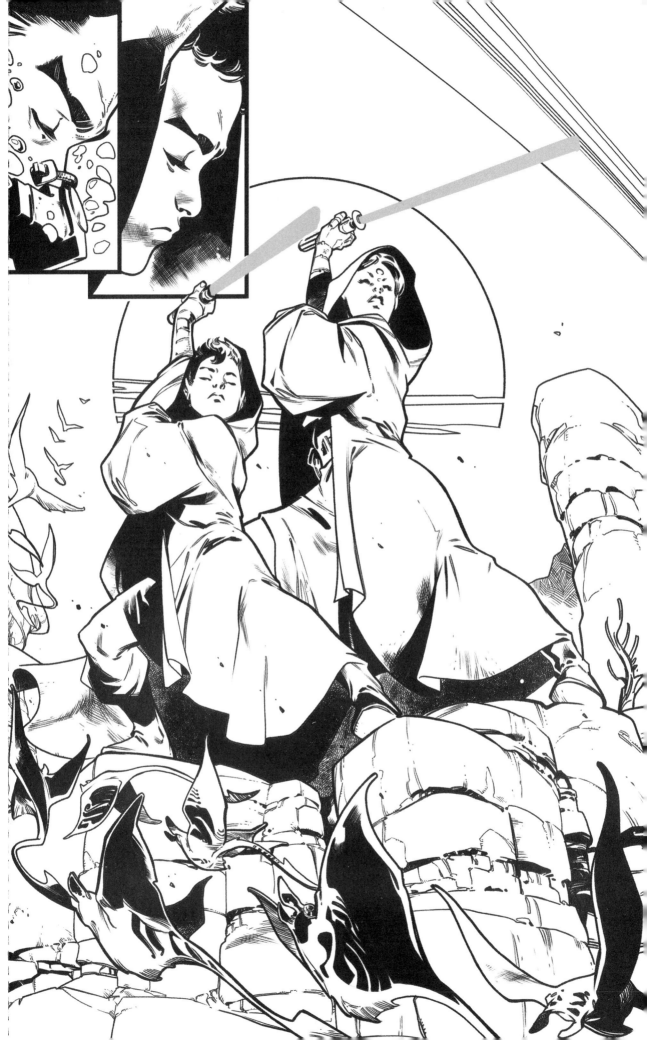

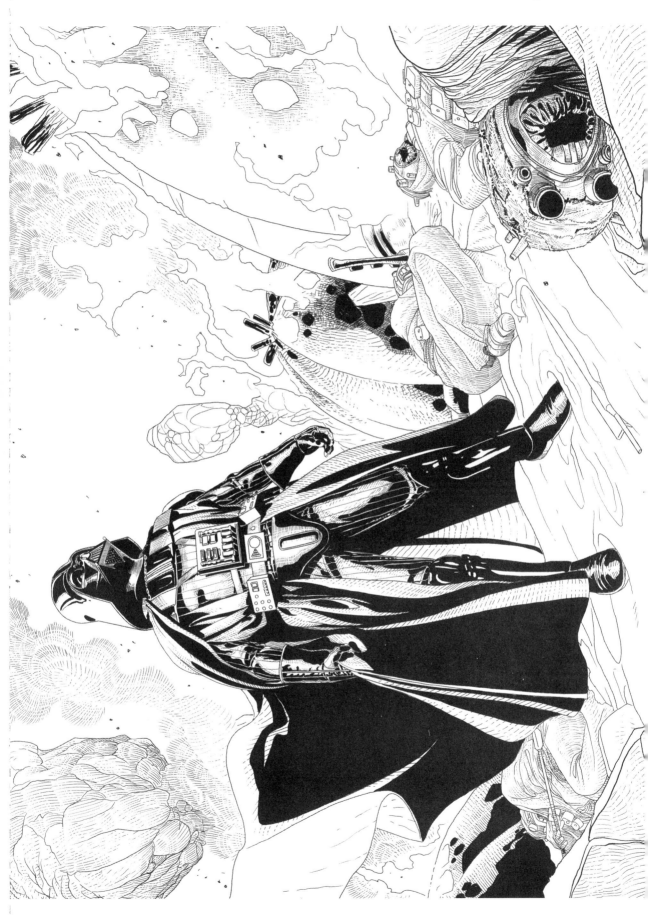